THORNBURY

THROUGH TIME

Tony Cherry & Meg Wise

AMBERLEY PUBLISHING

First published 2010

Amberley Publishing Plc
Cirencester Road, Chalford,
Stroud, Gloucestershire, GL6 8PE

www.amberley-books.com

Copyright © Tony Cherry & Meg Wise, 2010

The right of Tony Cherry & Meg Wise to be
identified as the Authors of this work has been
asserted in accordance with the Copyrights, Designs
and Patents Act 1988.

ISBN 978 1 4456 0162 5

British Library Cataloguing in Publication Data.
A catalogue record for this book is available from
the British Library.

Typeset in 9.5pt on 12pt Celeste.
Typesetting by Amberley Publishing.
Printed in the UK.

Introduction

This book photographically reflects changes in Thornbury over the last 130 years. There are broadly four elements to change: political, social, economic and technological. They almost invariably interact with each other. A comparison of photographs will often illustrate one or more of those elements.

In compiling the book we have chosen to assemble the photographs in the following sections:

Thornbury Market and the Butchers

Recorded in the Domesday Book of 1086, Thornbury's market became its *raison d'être* when the Lord of the Manor granted a town charter in 1252. For a further 650 years the holder of that office had the rights to the markets held in the centre of town. It was only when the livestock market moved from the High Street that he relinquished his rights.

Thornbury remained a relatively small town for centuries. But its influence extended over a wide area because of its market. There were always several butchers in the town with their own slaughterhouses behind their retail premises. In 1960 there were still seven butchers in town who operated their own abattoirs. Gradually there was a fall as slaughterhouses disappeared with new legislation. The number of butchers declined and by the Millennium there were no butchers in the town centre.

Thornbury Architecture

Thornbury High Street would in large part be easily recognised by someone who left the town 50 or even 100 years ago, providing, that is, that they kept their gaze at first floor or roof level. The shop fronts have undergone many changes. These indicate both the changes of trade and of shop design. But look at a photograph and ask where in the High Street a shop was located and the answer will often come flooding

back when the first floors and roof lines are observed. A large part of the town centre is now a conservation area – proving that political decisions can halt change as well as create it.

Thornbury's Retailers

Thornbury has always had a large group of independent traders. This has meant that, by their very nature, businesses have a finite life in the town. They last until the proprietor retires, unless the business is sold as a going concern or a family member takes over.

High Streets have always changed as fashions and trends have changed. The eighteenth century peruke maker disappeared when wigs went out of fashion. But one constant was that people both made and sold things. However, the disappearance in recent times of the baker, the clockmaker, the tailor, the draper, the milliner and the shoemaker has resulted in the disappearance of the long tradition of making things.

Thornbury at Work

The ways people work as well as the jobs they carry out have altered dramatically over the last century – the change from the horse to motor transport being just one example. Out went many of the saddlers and blacksmiths. In came garages, petrol pumps and car mechanics. Technological change has also had its effect in more subtle ways; for example, grocery orders are now made through the internet.

After the Second World War there was a strong aversion in the British psyche to being a servant. To be in service was to be subservient, an inferior person who worked for his or her betters. It is paradoxical that it is the skills of service which now dominate the High Street. We no longer make things and those working in the High Street rely on their service skills and knowledge to forge a living.

Thornbury at Play

The most striking change in Thornbury's social activities is the way the gender gap has diminished with for example women playing football and bowls and girls being members of cub packs. Increased prosperity has resulted in people eating out at restaurants (mostly foreign) and now most pub landlords rely on food sales to make a living. The influence of both pubs and churches to form our social groups has diminished and we now seek entertainment through a myriad of different outlets.

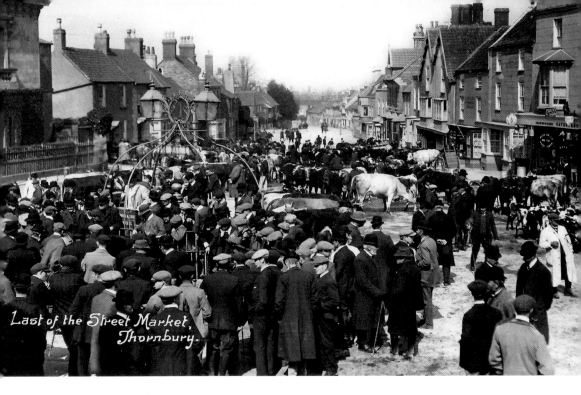

Last of the Street Market, Thornbury.

The Livestock Market

Thornbury market moved from the High Street and The Plain in 1911 because of pressure for a more sanitary site. It moved to a purpose-built location off Rock Street with easier access to the railway station. The tariff in the new market for selling horses was 1/- (5p). Market stalls were hired to pedlars and "cheapjacks" for 1/-.

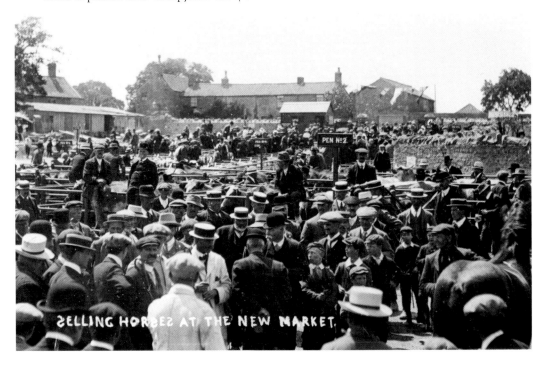

SELLING HORSES AT THE NEW MARKET.

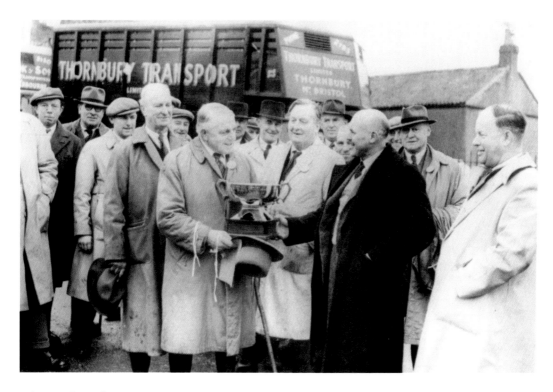

Prizes and Auctions

Thomas Ford receives the cup for the "best beast" at the Christmas Market 1952 from S. R. Luce. Thornbury Transport, seen in the background, was a haulage company created by Ray Till in the early 1950s. Although taken over in 1965 it was still operating well into the 1970s (see page 47). Walter Butt, auctioneer for Morris & Co, selling sheep in 1974.

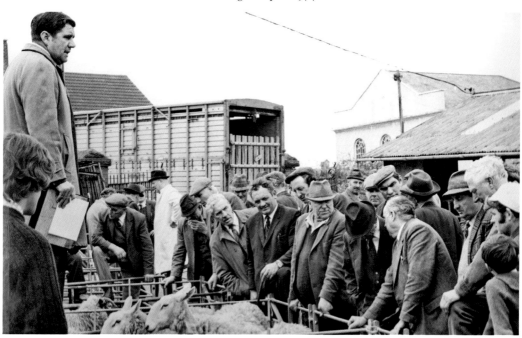

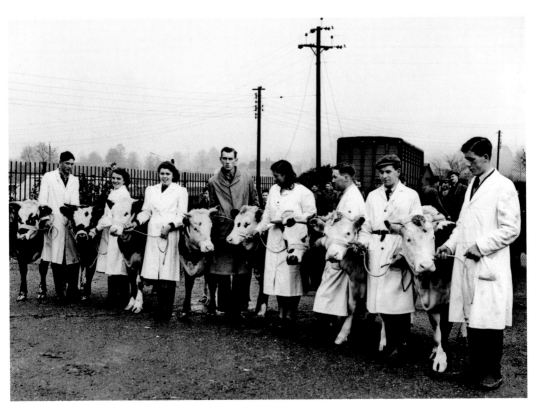

Prize Livestock

Above: young farmers parading their prize cattle in 1952. At the Christmas Market a variety of cups were awarded, including one for Best Beast, and there was even a prize for the person who purchased the most livestock. Right: Gordon Grey and Sally Cryer (later Grey) with their champion pen of porkers in 1962. The Grey family started farming in Rockhampton nearly 100 years ago and decendants now operate several farms in and around Thornbury.

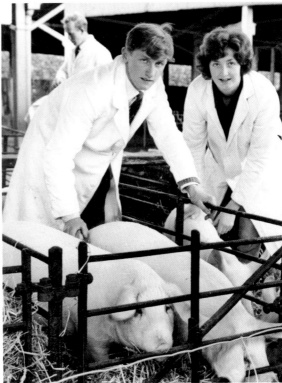

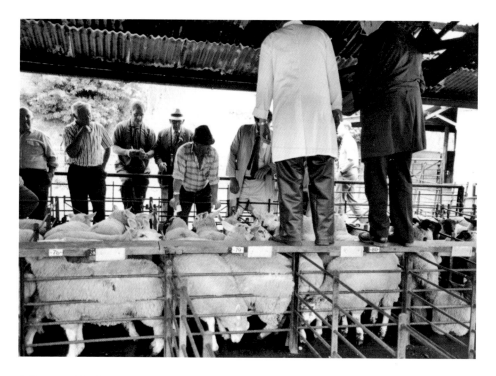

A Farmers Market

Above: the last sale of livestock at Thornbury Market in 1996. The meaning of "Farmers Market" has changed (below). A Farmers' Market at one time would have been primarily a trade market with limited sales to the general public. Now it is a market selling meat and other produce direct to consumers.

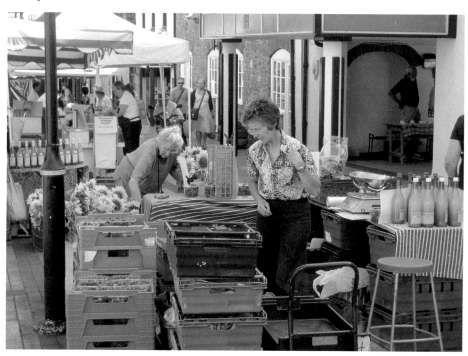

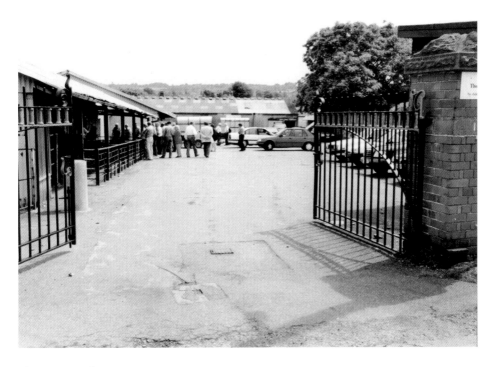

The New Market Entrance

After the closure of the market the site lay dormant (apart from overflow car parking) until the building of Turnberrie's Community Centre and new housing in 2007/8. The original gates and gateposts of the 1911 market have been incorporated into the boundaries of the housing development (inset).

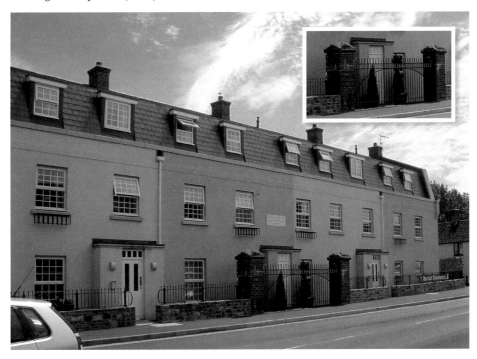

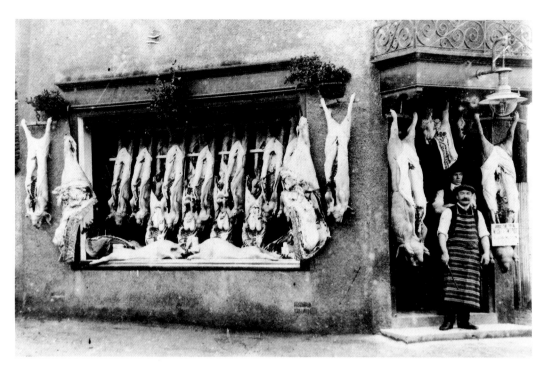

Pork Butcher
Specialist pork butcher Harry Trayhurn seen outside his premises, which had a slaughterhouse at the rear. The shop traded until the 1960s.

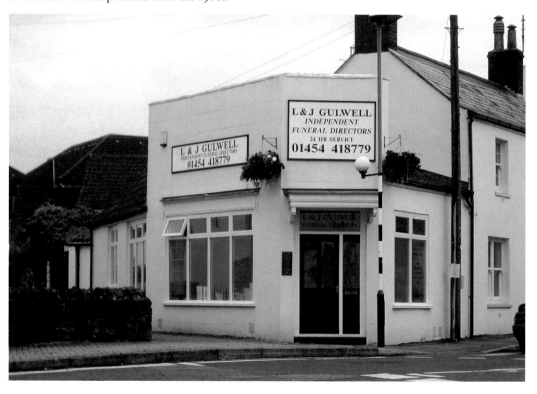

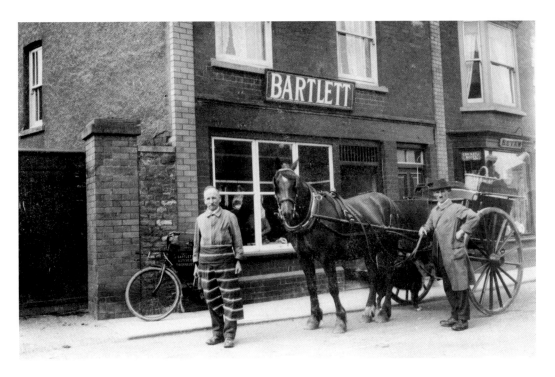

The Plain

A butcher's existed on this site for over a hundred years. Bartlett's also had a slaughterhouse on the premises. The shop was a butcher's until the 1990s although the slaughterhouse had been disused for some 30 years. To the left of the gates was a weighbridge used at the High Street Market. The property is seen below as ladies' dress shop Box 2.

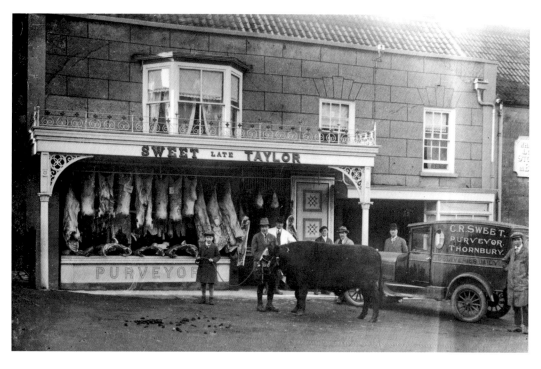

26 High Street
Sweets traded at the premises from the 1930s until the 1950s. The outbuildings where cattle were housed before being butchered are still in existence at the back of the building.

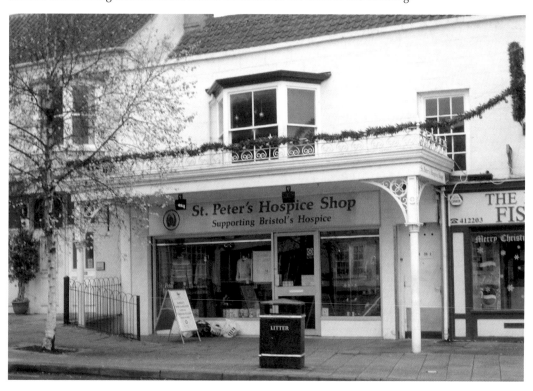

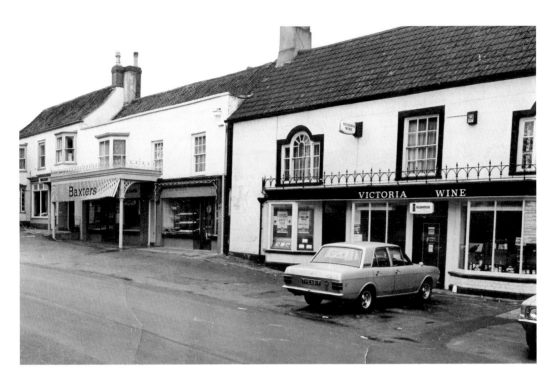

Specialist Butcher's

Baxter's butcher's occupied 26 High Street. Their neighbours included Owen's fruit and veg. shop, Hartnell Taylor estate agents and Victoria Wine. Baxter's moved into the arcade and later closed down. Thornbury was without a specialist butcher for several years in the town centre until the opening of Traditional Meats of Thornbury in the St Mary Centre in 2008.

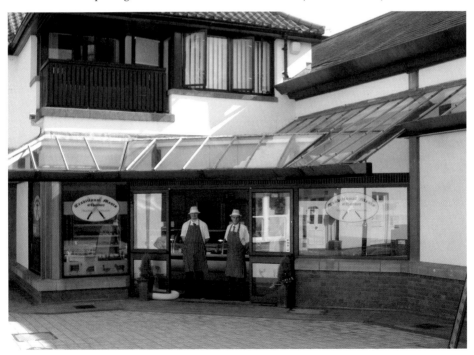

Same but Different

Over the space of 100 years many of the shops have gone as the buildings changed to dwelling houses. Shop fronts have disappeared and shop signs have been replaced by bus and street signs. Chimneys have also been removed.

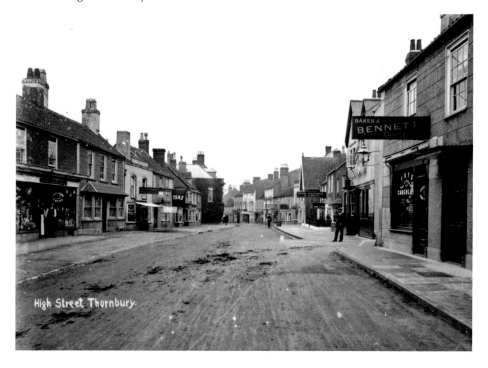

High Street Thornbury.

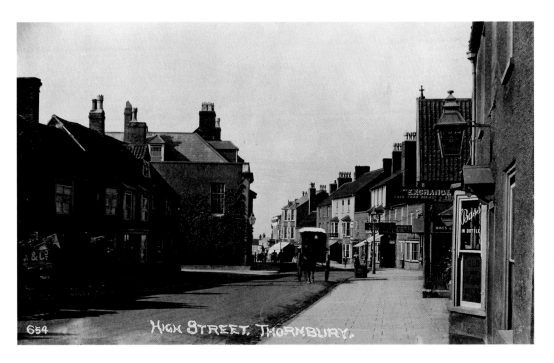

High Street and the Junction of The Close

The ivy cladding and railings on the building on the left hand side have been removed. In the centre, the water trough and pump have long disappeared. In 1911 publican R. H. Smith was advertising that the Exchange was "free from brewer and distiller". The pub name has changed, as have its promotional signs, which now advertise giant television screens and Nintendo Wii.

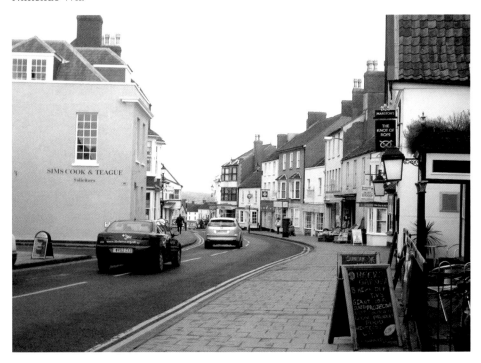

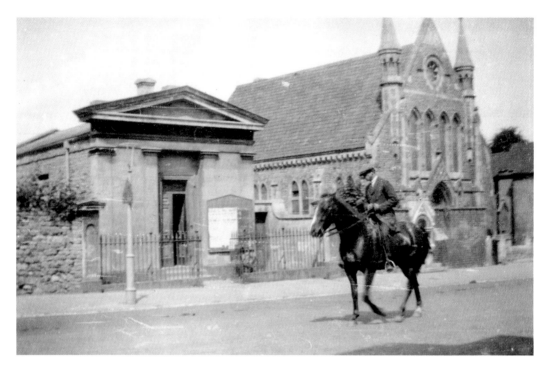

6 High Street

In the 1830s the Register Office was due to be built next to the workhouse in Gloucester Road. But the social stigma of being seen even walking towards the workhouse forced it to be located in the High Street instead (see left). The photograph above predates the building of the Fire Station in 1930 (now occupied by Southern Fried Chicken).

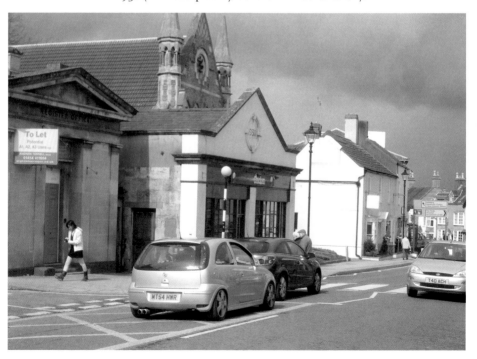

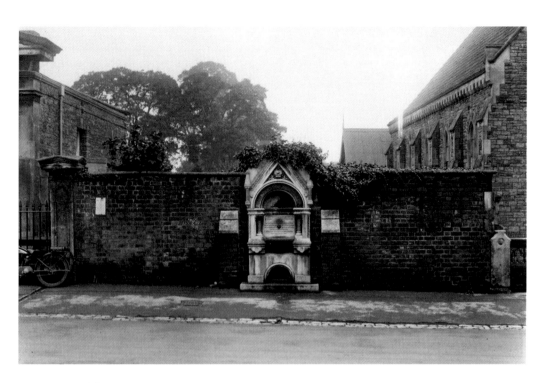

Memorial

The water fountain erected by public subscription in memory of Lieut. Hector Maclaine, shown in its original location of the High Street. When the Fire Station was erected the memorial was incorporated on the front of the building and was only relocated when the station doors had to be widened. It is now situated on the corner of Latteridge Lane on the boundary wall of Nat West Bank.

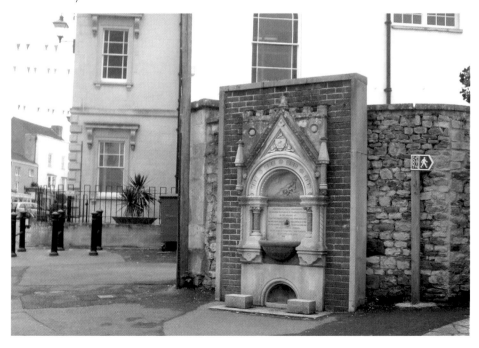

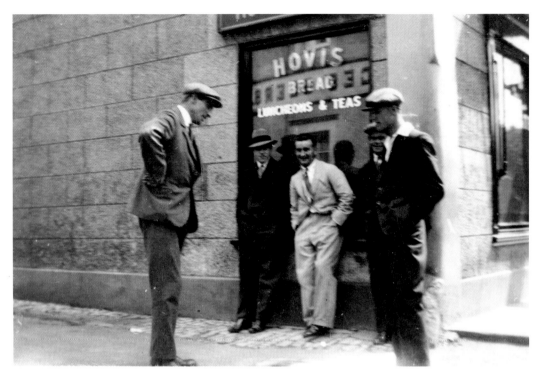

The Junction of the High Street and Chapel Street

The corner property was a bakery operated by the Thompsons between 1912 and 1959. Albert Thompson was succeeded by his sons Denis and Henry (Henry is seen inset below right next to his wife Grace). Thompsons operated two shops in the High Street and the one shown above was known as the "top shop".

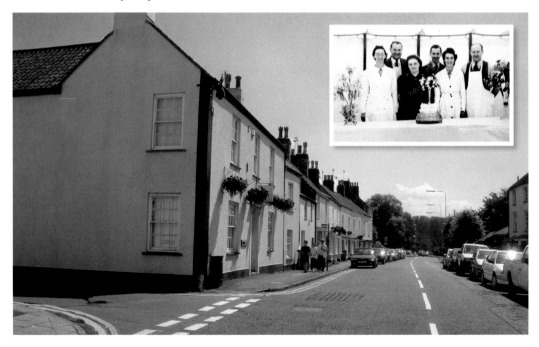

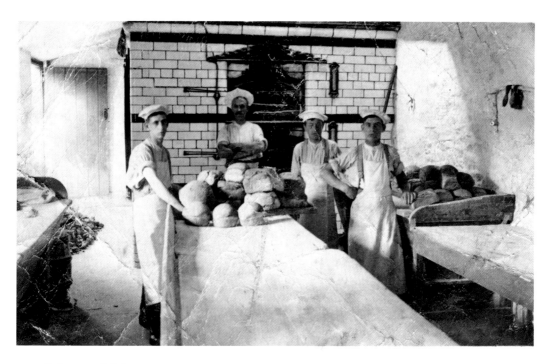

Bakery and Cakes

A. E. Thompson (second left) in his bakery in 1918. Thompson grew his delivery rounds and just after the Second World War had two horse-drawn carts and three motor vans. Below: little is known about Thornbury baker and confectioner R. Trayhurn whose delivery cart is seen here outside the Swan Inn at Tytherington *c.* 1913. The adverts on the vehicle suggest that he specialised in cakes and pasteries rather than bread.

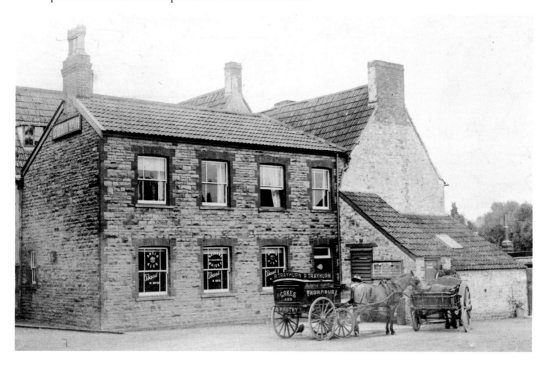

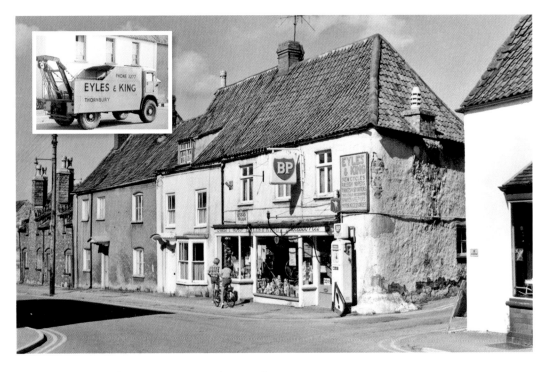

The Corner of St Mary Street and Horseshoe Lane

Eyles & King were general engineers and sold motor accessories, cycles and petrol (the petrol pump site is still visible). Their breakdown vehicle is seen inset. Lower down the street, the ground floor of the third building has given way to a walkway through to other parts of the pedestrianised St Mary Centre.

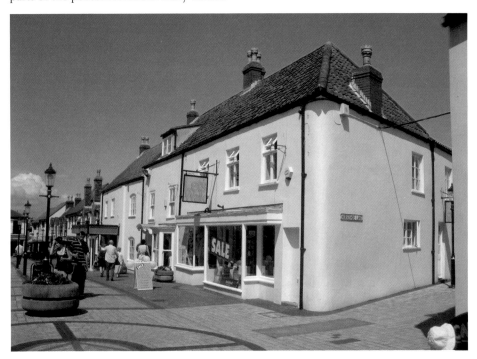

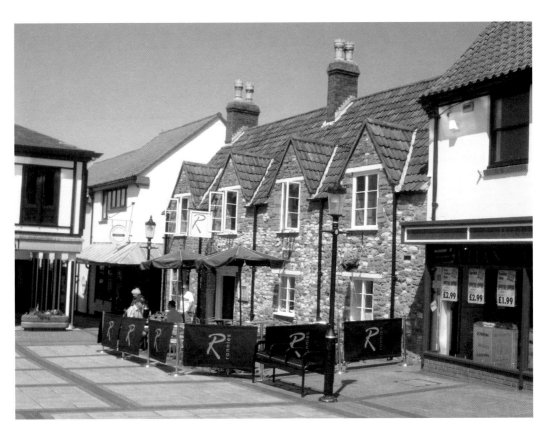

St Mary Street/St Mary Centre
Ronnies, winner of the 2009 top award issued by Good Food Guide, now occupies the seventeenth century property. Amongst other things, the building has served as Atwells Free School, a temperance coffee tavern and the Church Institute.

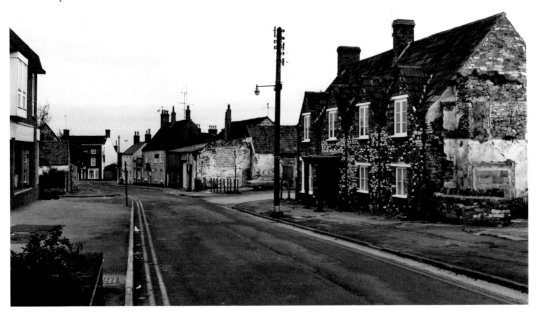

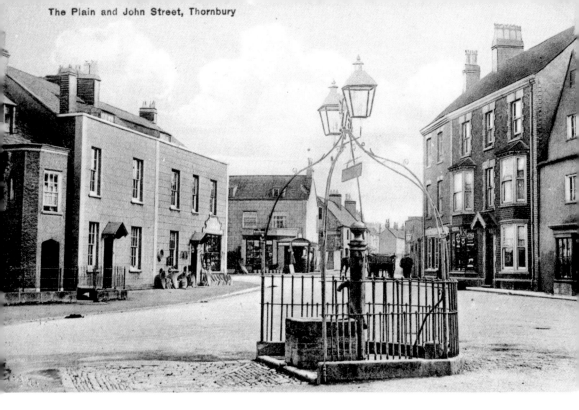

The Pump

The pump was erected circa 1860 and removed by the Rural District Council in 1924 because it was no longer in use and was regarded as a road hazard. Disgruntled residents can be seen trying to resurrect the pump. The Rural District Council won the battle and it was taken away, the town losing a major feature.

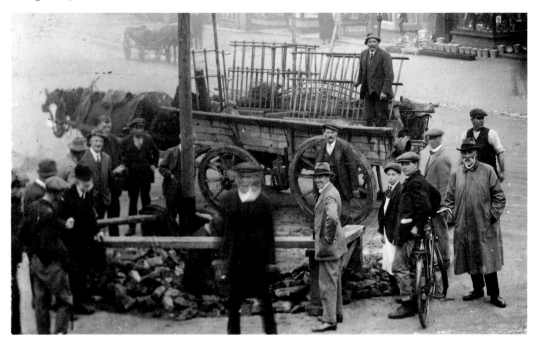

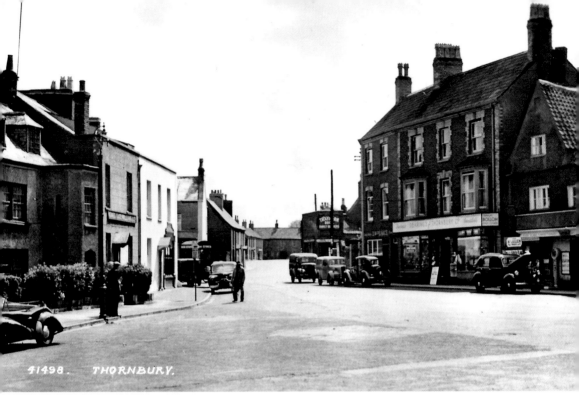

The Pump Returns

The Plain was without a pump for sixty years until an old pump retrieved from Bath Road was installed together with replica railings and surroundings. The new pump is not in the exact spot as the original but makes a focal point for the town centre, especially when adorned for Thornbury in Bloom.

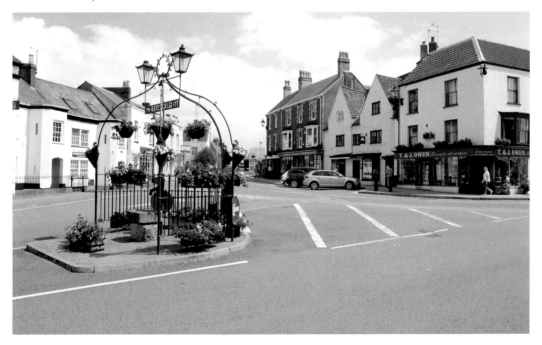

The Council Offices
The Council Offices at the bottom of Castle Street in both their old and new guises. Stokefield House (above) was originally built as the private residence of Adrian Stokes at the beginning of the nineteenth century.

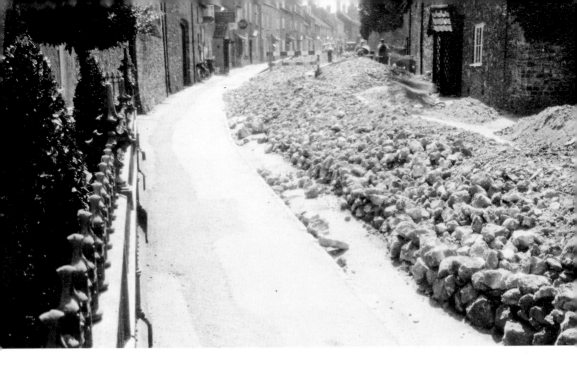

Castle Street

In 1935 the laying of sewage pipes in Castle Street proved very difficult because of the Thornbury rock that underlies the town. The now demolished Stokefield Cottage can be seen on the right hand side. The later picture shows the entrance to the Chantry stable (now blocked off) and the porch on the left hand side where Johnny Bond's cycle shop was located (see page 49).

Gas Works

The gas works were built in 1855 and the manager's house is seen above. It was located in Backchurch Lane – known by some as Gas House Lane – now named Park Road. Through the trees Manorbrook School, built in 1969, can be seen in the recent photograph.

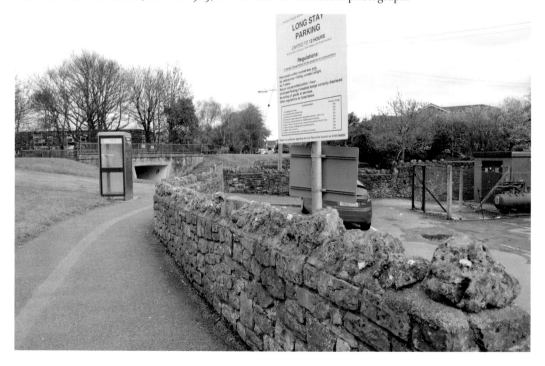

Thornbury Council School, later The Leaze School

Thornbury Council School was given temporary classrooms after the Second World War to cope with the increased numbers resulting from the raising of the school leaving age. The classrooms were then used by The Leaze School as the town expanded during the 1960s. Having been unoccupied for over thirty years, the classrooms were demolished to make way for housing in 2008. The new road is called Leaze Close, recalling the Leaze School that the housing has replaced.

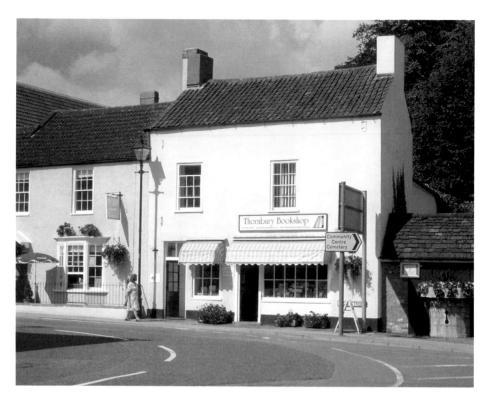

2 High Street

David Smith retired in 2008 after thirty years at this shop. He had moved there having traded from 3, The Plain for the previous eight years. The later photograph shows the separate access created to the top floor of the building and the loss of the garage.

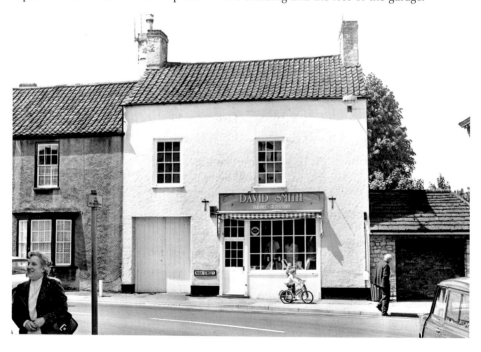

14 High Street
This eighteenth century building was the Market Hall. The lower part was open air, apart from the area under the stairs where the town gaol was located. In the twentieth century it became a shop, firstly as Weatherhead's followed by Beaven's, Worthingtons and now Wildings.

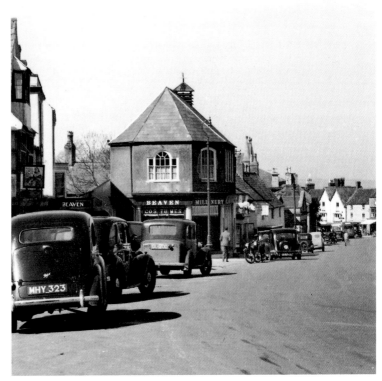

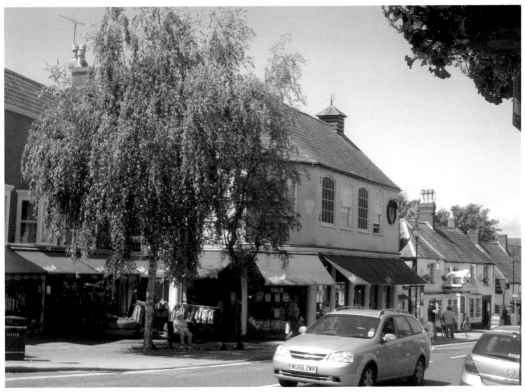

W. YARNOLD, Thornbury.

Watchmaker, Jeweller, and Optician.

A good selection of Watches, Clocks, Electro Plate, Wedding and Keeper Rings stocked. Spectacles to suit all Sights.

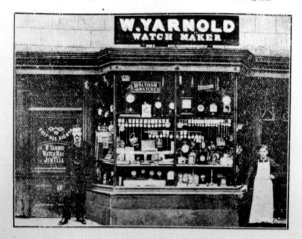

Special attention given to Repairing of Watches, Clocks, and Jewellery. Agent for Pratt's Motor Spirit.

16 High Street

William Yarnold was known to be lodging at the premises in 1881 and trading from 1889 as a watchmaker, jeweller and optician. The keeper rings advertised were worn to "keep" other rings on the finger. In the early part of the twentieth century spectacles could be bought for 1/-, including the case. Various estate agents have occupied the property in recent times, the latest being Chappell & Matthews.

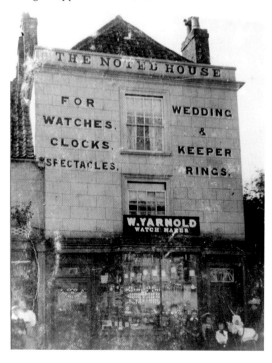

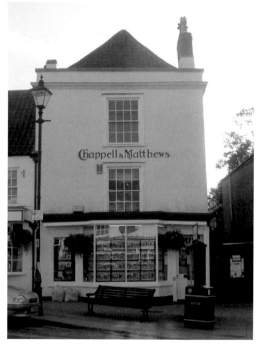

28 High Street

Seen right, SEW-N-SEW catered for those who made their own clothes and soft furnishings. Reflecting social changes and in keeping with changing food tastes, the premises have become a Thai Restaurant. In 1877 seedsman and ironmonger Henry Robbins operated a sub-post office from this building. Robbins was succeeded in about 1914 by stationer Charles Pitcher who was sub-postmaster for forty-seven years.

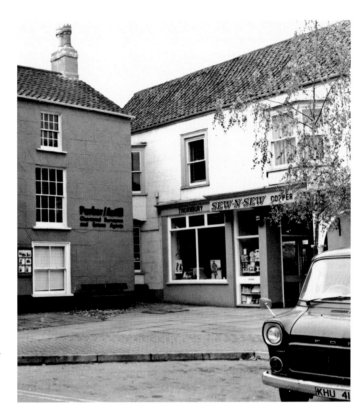

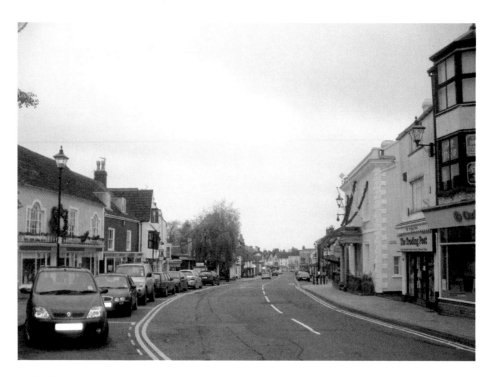

High Street Retailers *c.* 1909 & 2009

Right: G. B. Symes (tailor) now Oxfam, A. C. Huins (boots & shoes) now The Trading Post, Police Station now Town Hall Left: Anstey's (off-licence) now Heritage Gift Shop, Prewett's now Horder's (stationers), Weatherhead's (house furnishers) now – hidden behind the tree – Wildings (outfitters and household goods).

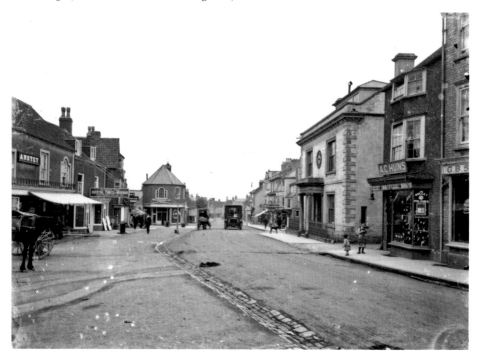

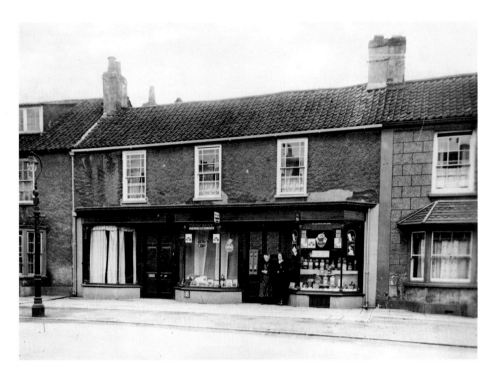

56 High Street

The older photograph was taken on 1 March 1935 (shopkeepers unknown). Advertisements for tobacco and cigarettes were legal at the time and the right hand window reads "For your Throat's sake Smoke Craven A". A later occupant was the Midlands Electricity Board who used the premises as a show room until shortly after the nationalised power companies were privatised in 1985.

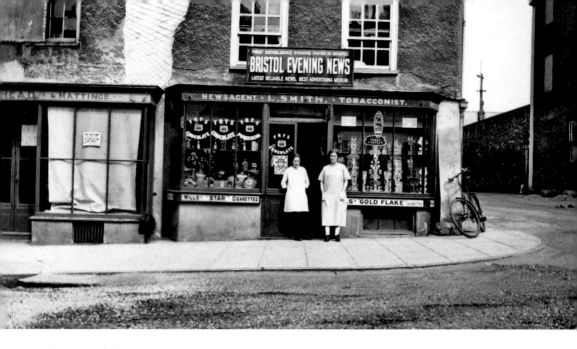

Sweets and Treats

Mrs Len Smith (right) standing outside her husband's newsagents, tobacconists and confectioners on the corner of the High Street and Silver Street. Len Smith owned the shop from 1924 to 1945, when he sold it to Barron's. Today the building houses part of the Britannia (see page 60). Below Edna Fudge is seen in her shop The Candy Store (3, High Street). Mrs Fudge took over the sweet shop in 1966 when Annie Pitcher retired at the age of ninety. A jeweller now occupies the premises, trading under the name Gems of Thornbury.

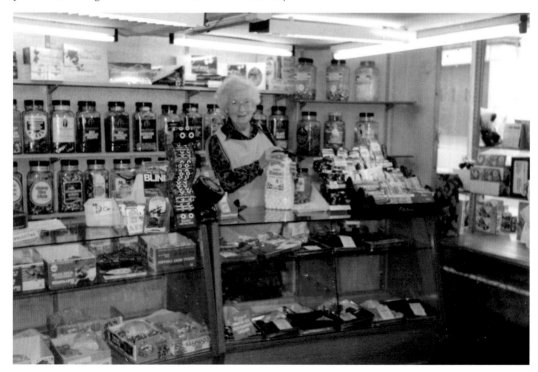

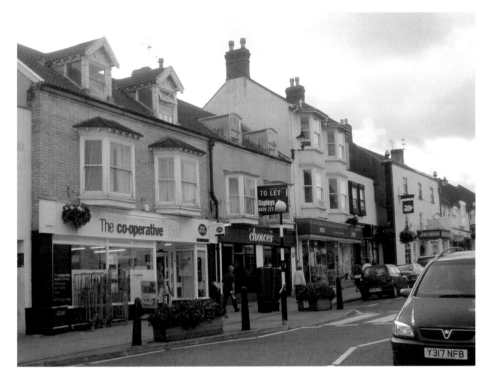

7-9 High Street
The Co-op returned to the town in 2003. Choices video shop closed when the film distributors changed the way films were released to the public making film rentals less attractive. The International left the town in the 1980s.

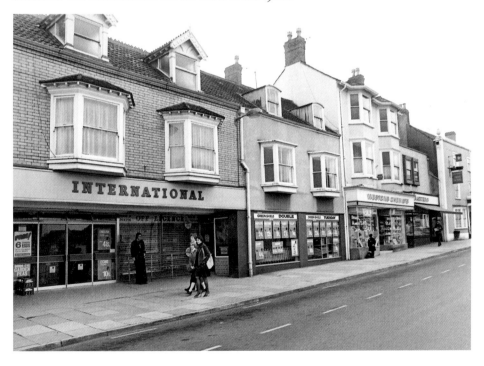

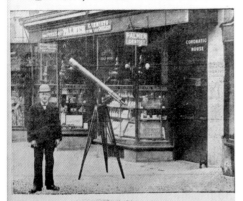

J. Spencer Palmer
M.P.S., R.D.S.
Chemist & Dental Surgeon,
High St., **THORNBURY.**

Dental From 10 a.m. to 6 p.m. THURSDAYS EXCEPTED. **DAILY.**
Attendance

Pure Drugs, Chemicals and Photographic Requisites.

Horse and Cattle Medicines, and all Agricultural
: : and Farm Chemicals, &c. : :

13 High Street

Built in 1901 as Coronation House, in anticipation of the coronation of Edward VII, at a cost of £1,019 by Tucker Bros (see page 74) and occupied by James Spencer Palmer, Chemist and Dentist. He was also an optician and provided veterinary products. He originally came to the town in 1891 and traded from the shop on the corner of The Plain and the High Street until he moved into the new premises. His hobby was astronomy although hc was also interested in clocks and watches. He kept a talking grey parrot in the shop which amused customers. The premises now reflect the national trend of a growth in charity shops.

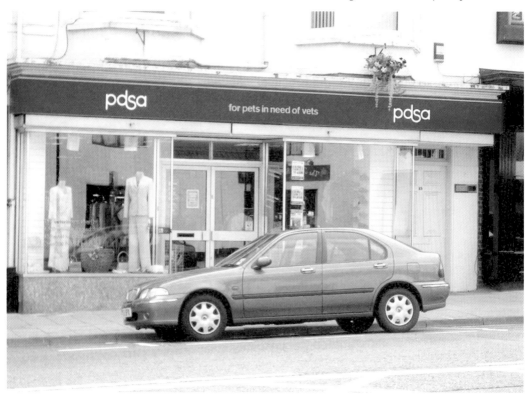

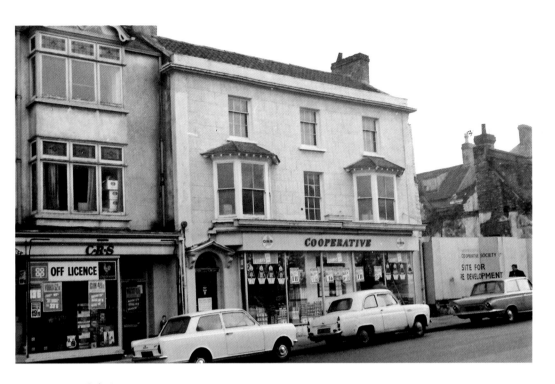

25–27 High Street

The premises were occupied by Councells for over 100 years and were taken over by the Co-op around 1950. The Co-op sold furniture, shoes, groceries, and hardware and had an off-licence. When the Co-op moved into the new St Mary Centre it only sold groceries. By the 1990s the Co-op had left the town altogether returning in 2003 (see page 35). The entrance to the St Mary Centre has changed since this photograph was taken when it was newly constructed.

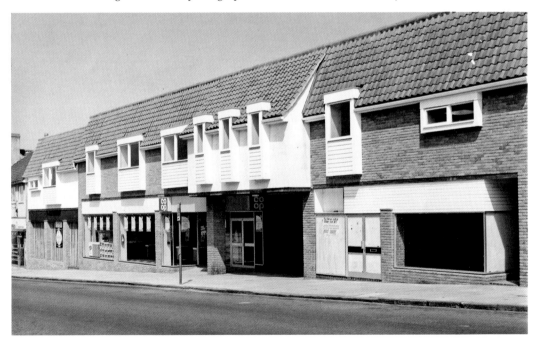

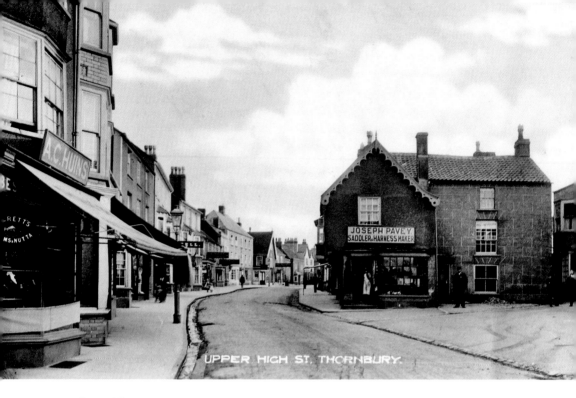

The Saddlers

The site occupied by Joseph Pavey was a saddlers for at least 120 years (previously Burchell's and before that Embley's). The white gas lamp just visible on the right advertised the Post Office. The lamp and its fittings are preserved in the collection of Thornbury and District Museum.

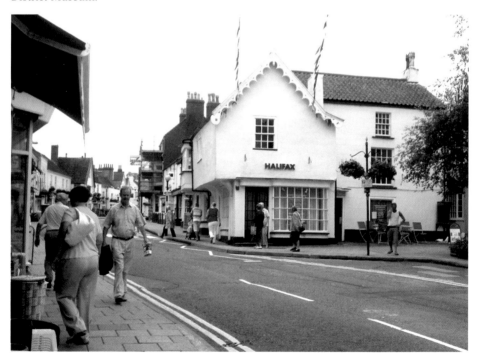

The Post Office

The sub-post office is seen far right below before it moved to 7-9, High Street. Granny's Attic Antiques took over the premises and it is now occupied by Manns opticians. Julian Flook was a grocery store.

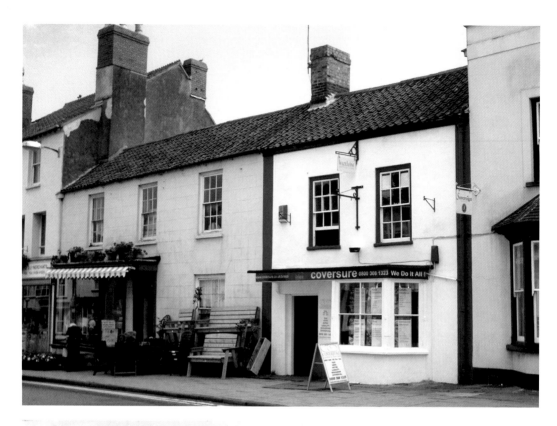

Thomas's Boot Stores

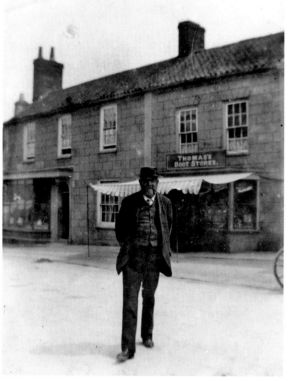

The picture (left) from the early part of the twentieth century is thought to depict the store owner. At the time boot and shoe shops were common in the town but 100 years later there are none. The recent photograph shows the premises occupied by John Williams, Insurance & Mortgage Brokers before they moved to Tewkesbury. Nextdoor is a grocery store. Trading as Butt's, it became Dent's and was then purchased by Lionel Riddiford (see page 70).

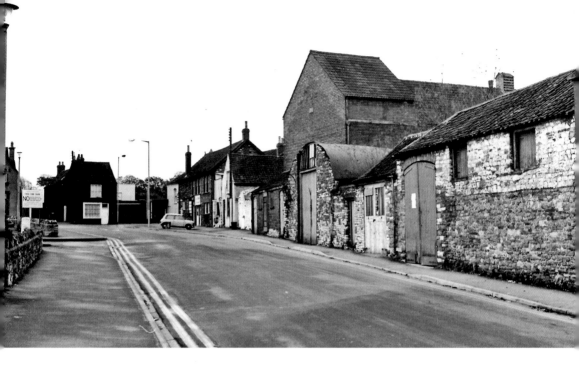

Museum

The museum can be seen facing St Mary Street. In the earlier picture the building was a dwelling house. The very tall building on the right hand side housed the screen of the cinema.

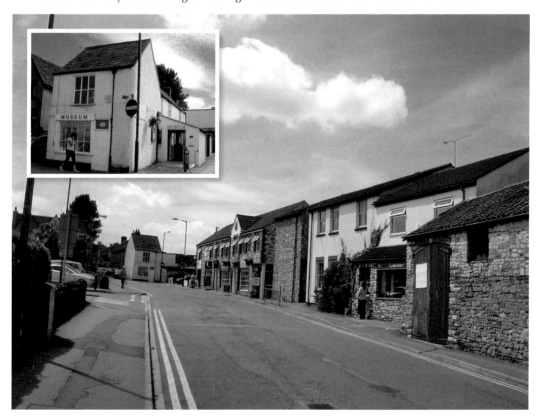

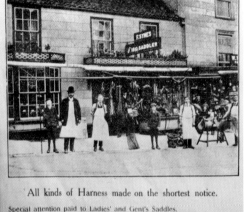

18 High Street – From Saddler to Beauty Parlour

The Symes family did not always trade from these premises. The last of the family to do so was Frank Symes who retired in 1926 after nearly fifty years in the trade. He was succeeded by his former apprentice Lawrence Roach. Later Francis Hopkins ran a grocery business from here (see page 71). The shop is now divided in to two parts, one of which is Troupers Beauty Parlour.

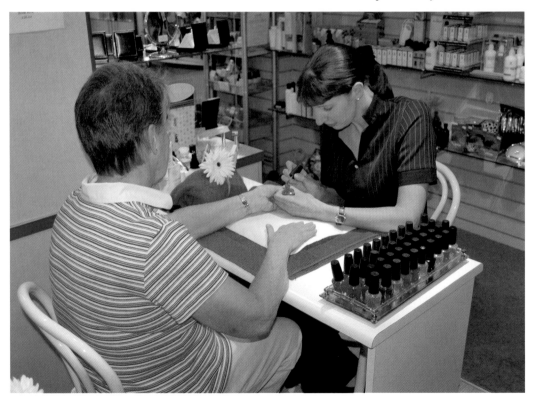

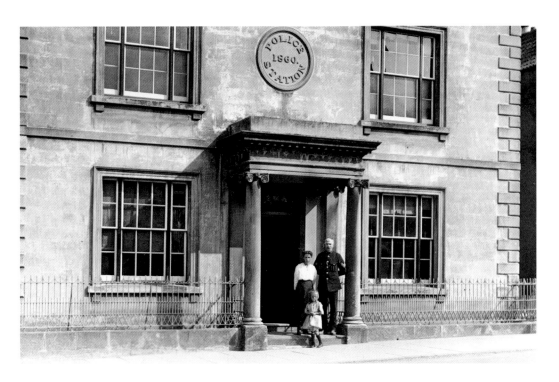

From Police Station to Town Hall

This building was originally the home of solicitor William Rolph and was converted to a Police Station and Magistrates Court in 1860. The police sergeant, his family and several constables lived on the premises. The building became the Town Hall in 1994 and Thornbury's 2009/10 Mayor Phyllida Parsloe is seen outside the building.

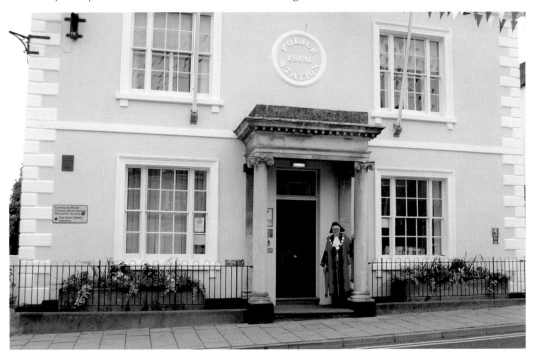

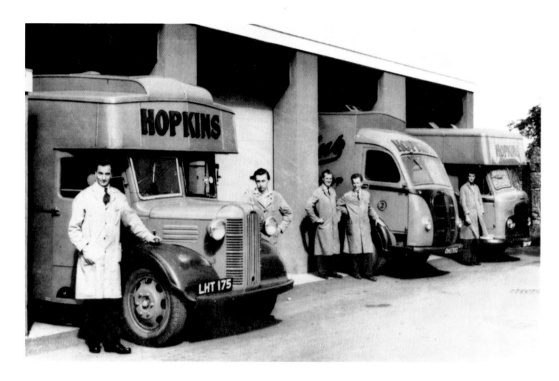

Home Deliveries

In the 1950s High Street grocer Francis Hopkins had a fleet of mobile shops which took groceries to houses beyond the boundaries of Thornbury. Now, with the advent of internet shopping, the position is reversed and groceries are delivered to houses in Thornbury from outside the town boundaries. The deliveries below came from Bradley Stoke.

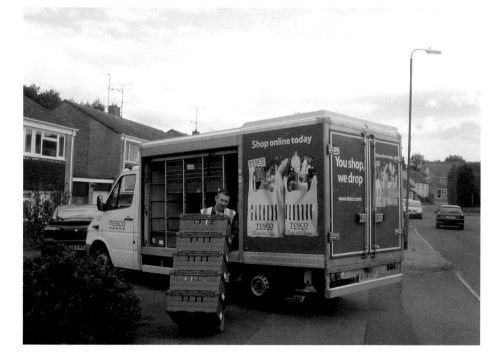

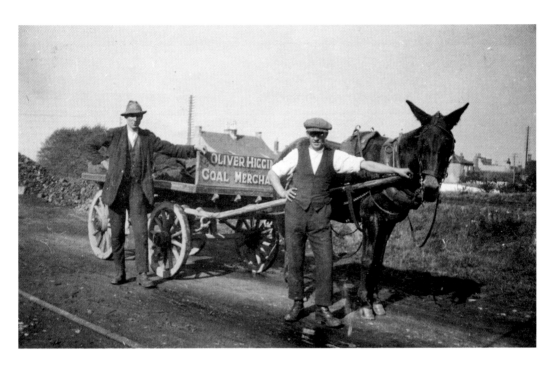

Home Deliveries

Both coal and milk deliveries were made to virtually every household as late as the 1950s but have diminished over the last fifty years. Coal is now delivered to approximately 2% of homes while milk is delivered to approximately 5% of homes. Blacksmith Oliver Higgins's son Nelson ran the coal business until First World War injuries forced his retirement and the closure of the business. John Richings was a Thornbury milkman from 1965 to 2004.

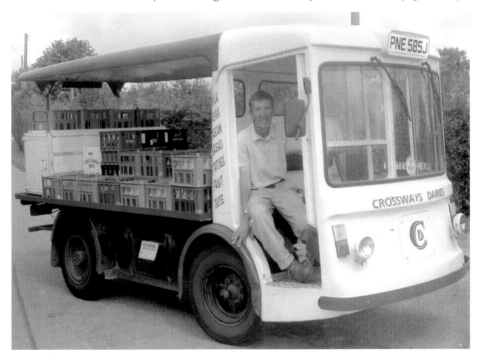

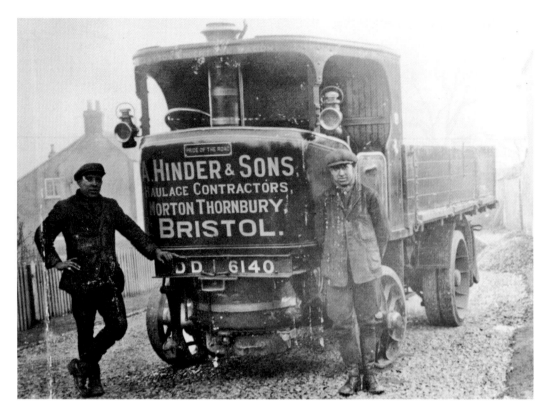

The Age of Steam

Hinders haulage business was located at Duck Hole, Morton, Thornbury and they were known to work for the local quarries. Thornbury Rural District Council had a fleet of steam lorries and steam rollers in the late 1920s. Some of the council lorries had a speed limit of 12 mph.

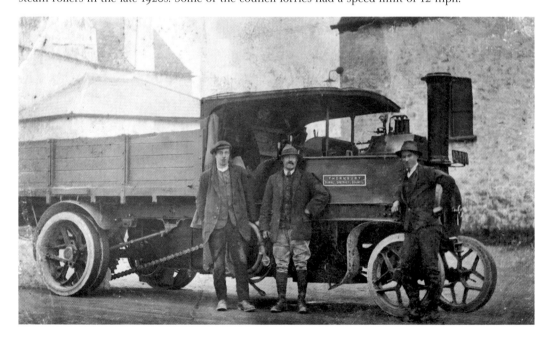

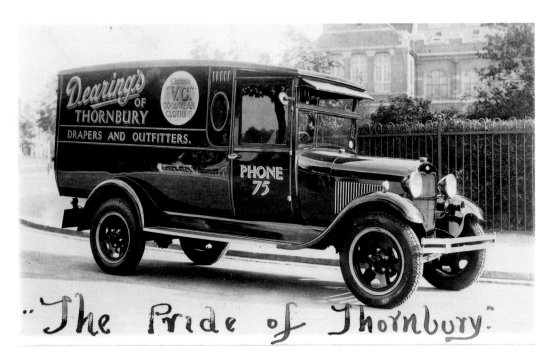

"The Pride of Thornbury."

Haulage and Delivery

Dearing's new mobile shop seen on the day it was purchased in 1929. Sidney Dearing took over a boot and shoe business from a family member James Bevan (see page 53). Sidney expanded the business from boots and shoes into other areas. Below: Ray Till had been operating this transport company from Morton, but moved to Gloucester Road around 1939/40. He lost control of his business when haulage was nationalised after the Second World War. When road transport was de-nationalised by the next Government Ray Till created a new private company called Thornbury Transport (see page 6).

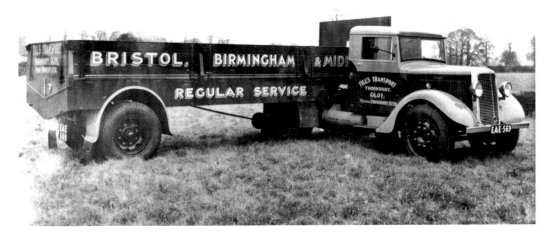

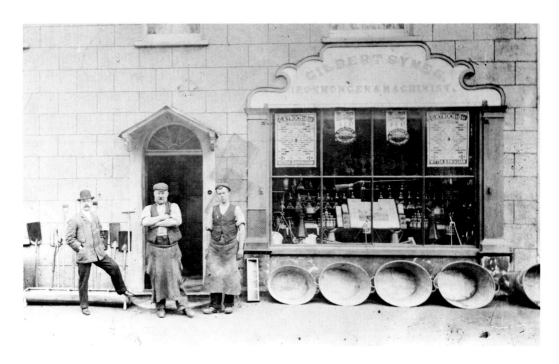

The Plain

A gun can be seen in the window of the hardware shop along with posters for ammunition. Gilbert Symes was also a blacksmith and occupied the property from 1898. The premises were previously occupied by the Savery family for twenty-seven years until they moved round the corner (see page 73).

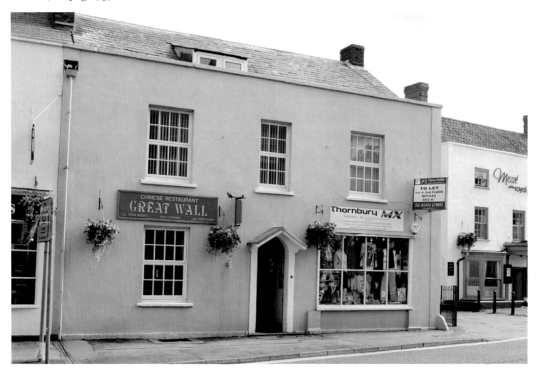

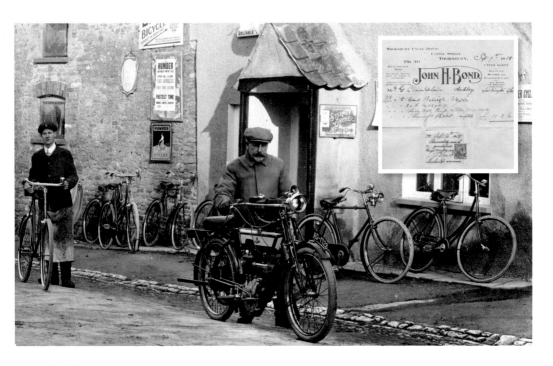

Bicycles

Outside Johnny Bond's cycle shop in Castle Street. The bill from 1918 (inset) is for a bicycle, basket and pump, total cost £11 2s 6d (£11 12½p). The bicycle shop below is located in Oakleaze Road and on display is the latest in carbon fibre cycles costing nearly £2,000.

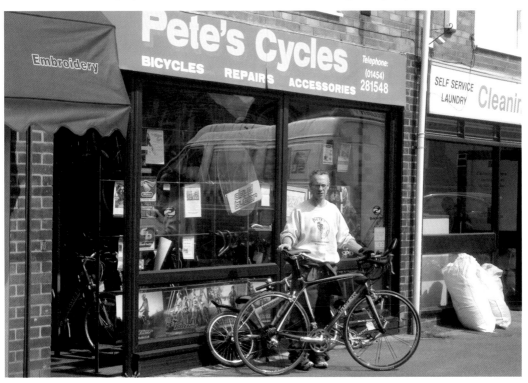

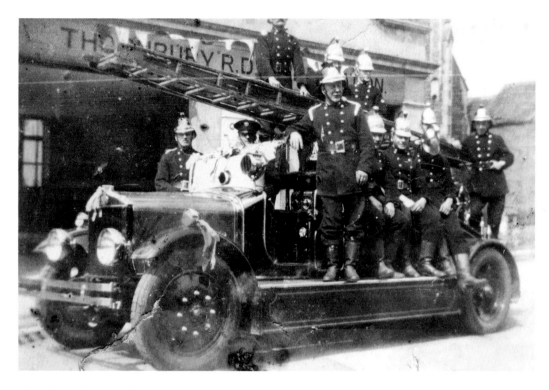

Thornbury Fire Brigade

1930s: the firemen, with brass helmets, riding on the running plate possibly on the day the new High Street Fire Station was opened. Today: based in the Gloucester Road, Thornbury's firefighters now include women. It is still a volunteer force.

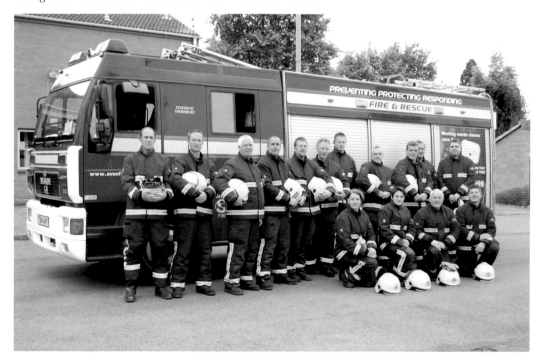

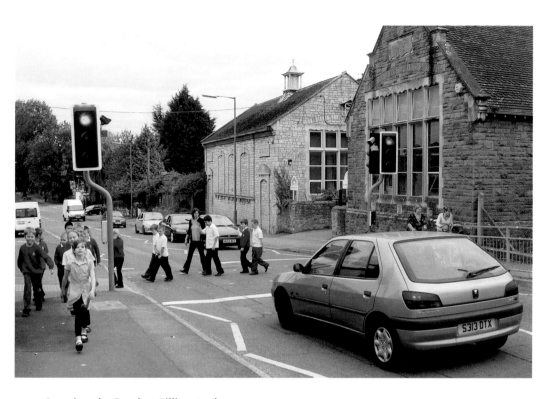

Crossing the Road at Gillingstool

The personal touch of the 1970s (below) gives way to automation. The school wall has now disappeared. Fashions have also changed. Girls wear trousers and boys wear long trousers.

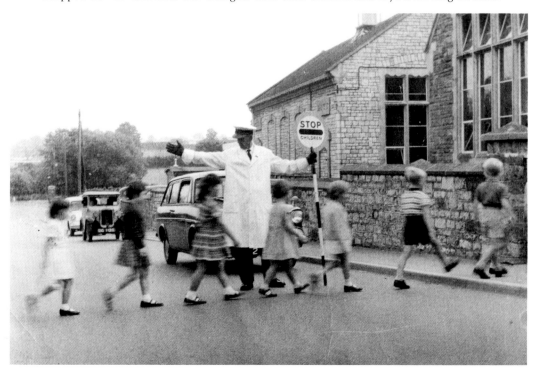

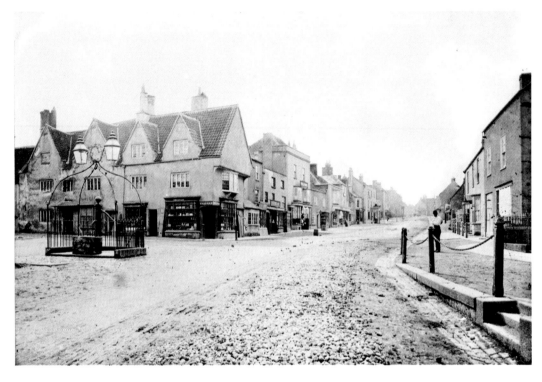

High Street Corner

Above: the corner shop had a gable end and gable windows when the property was occupied by Vaughan's the druggists. By 1897 the property had been altered as seen below. In 1902 J. H. Williams was a draper, silk mercer, mourning and funeral furnisher and collector of income tax. The recent picture shows florist Jean Owen (on the left) with her colleagues.

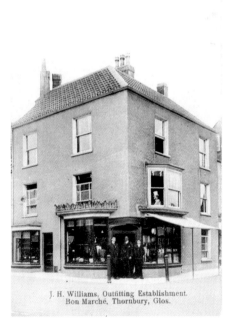

J. H. Williams, Outfitting Establishment. Bon Marché, Thornbury, Glos.

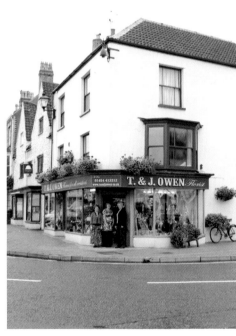

3 The Plain

The entrance porch has disappeared and the display windows have given way to a more discreet style reflecting the change from shoe shop to hairdressers. James Bevan made boots and shoes on the premises as well as selling factory made shoes. A newspaper advert for Bevan's from 1904 (inset) has ladies leather shoes from 2s 11d (just under 15p).

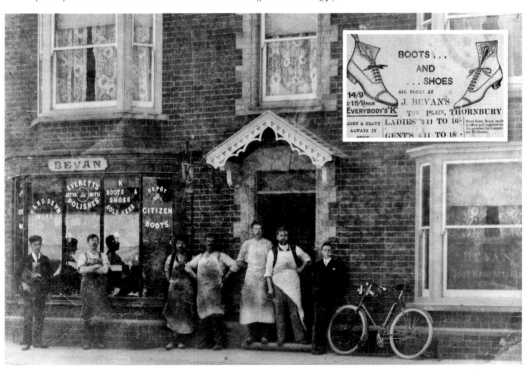

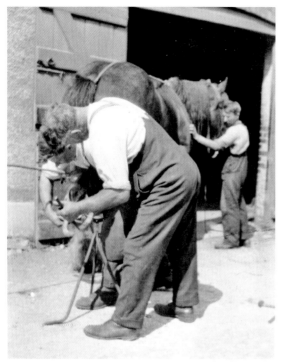
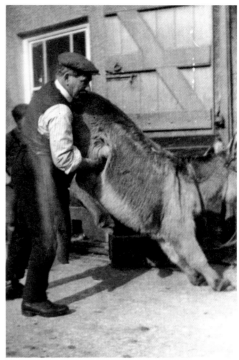

Maintaining the Transport

A horse being shoed and a donkey being shooed by Oliver Higgins at his Crispin Lane forge. Below: a car being serviced at Thornbury Motors in Grovesend Road.

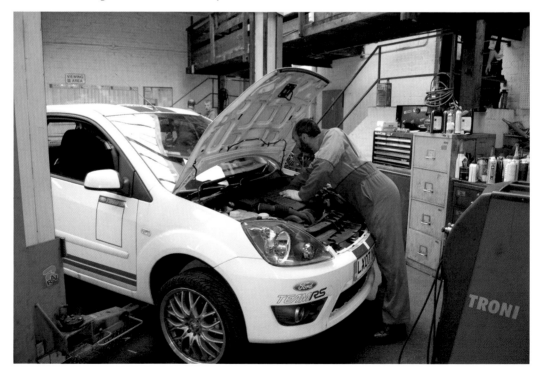

Wheels

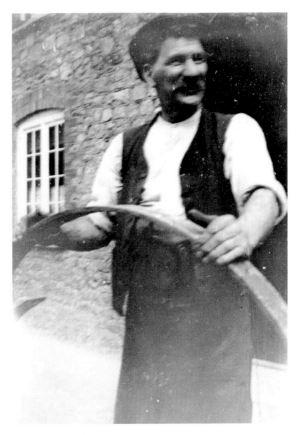

Oliver Higgins first started as a blacksmith in Thornbury in 1885 when he took over from Mark Williams. The trade was very much a family tradition. His father Jepthah was a smith, as were his brothers Jepthah and Gilbert. Higgins specialised in dealing with shire horses whilst Gilbert Symes specialised in hunters and ponies (see page 48). Higgins is seen maintaining the wooden wheels of the 1920s by bending metal rims to fit round the outside. Wheel maintenance is now carried out by, amongst others, Kwik Fit in Cooper Road.

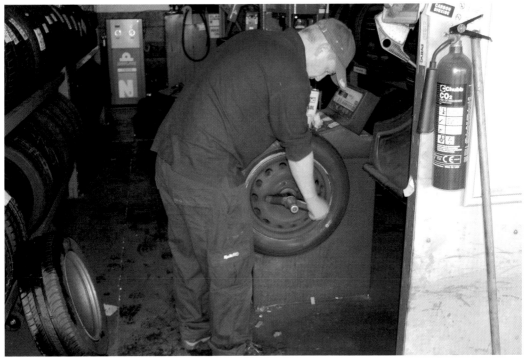

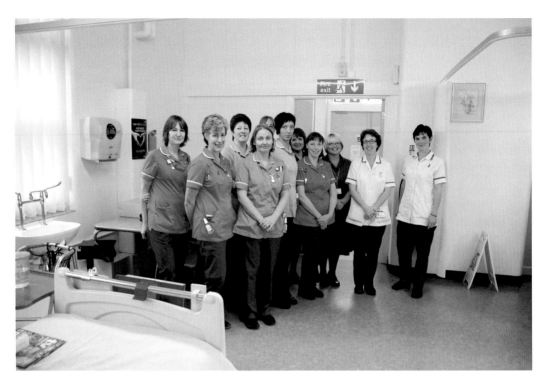

Nurses

Matron, nurses and staff of Henderson Ward, Thornbury Hospital (above). Uniforms were strikingly different at the 1950s Carol Service.

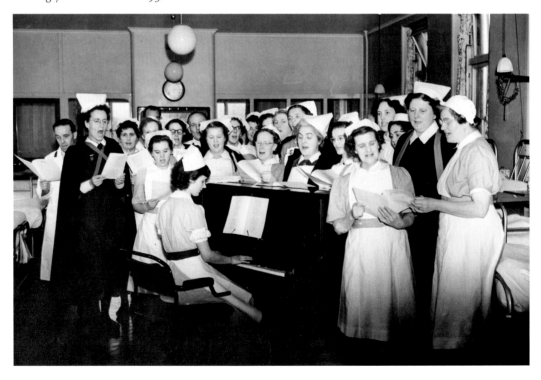

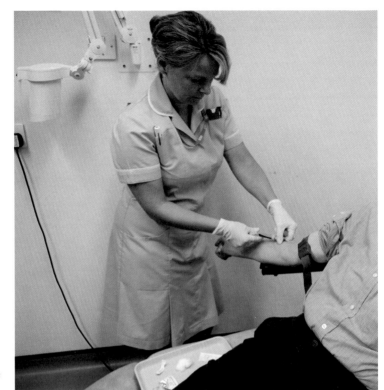

Nurses
A nurse taking blood at the Health Centre, demonstrating the way her role has evolved. Nurses at Thornbury Hospital's teaching unit boning up on anatomy in the 1950s.

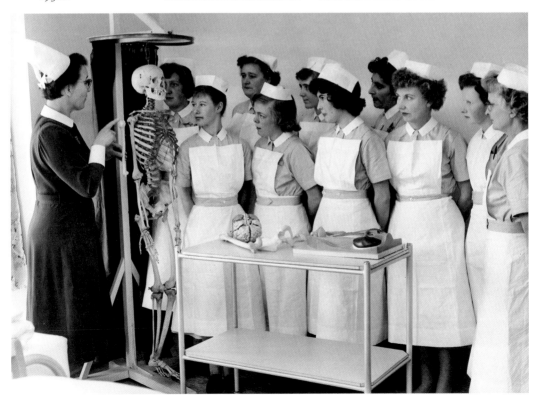

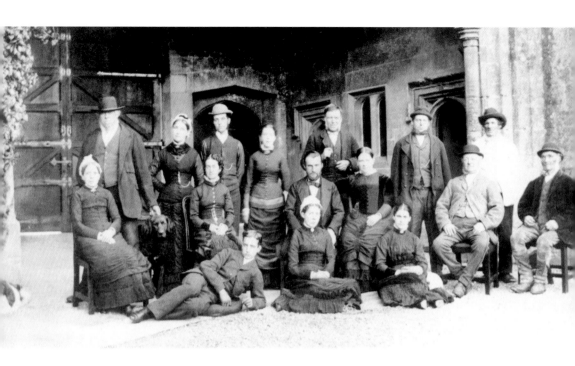

Thornbury Castle Staff

In 1882 when Thornbury Castle was the private residence of Sir E. Stafford Howard the servants included the gamekeeper, housekeeper, butler, maids, coachman and groom, accompanied by Dash the dog. The staff of Thornbury Castle Hotel includes the manager, housekeepers, chefs, waiters and receptionists, accompanied by Dodger the dog.

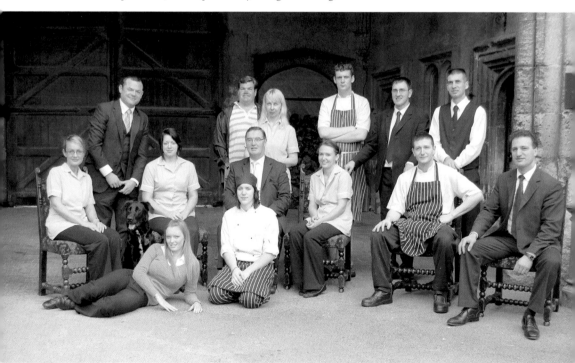

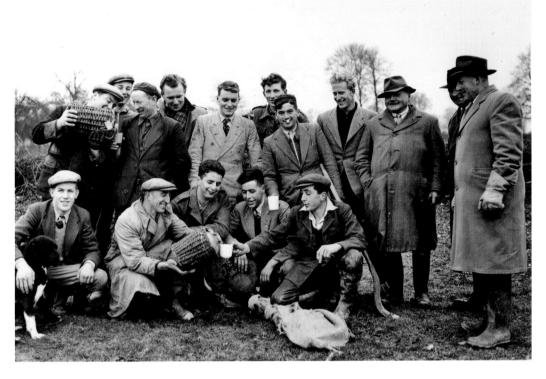

What's your Tipple?

At a hedging and ditching competition in 1956 competitors enjoy the local cider. Growing grapes for wine making at Thornbury Castle. The grapes are being tended by viticulturist Ingrid Bates.

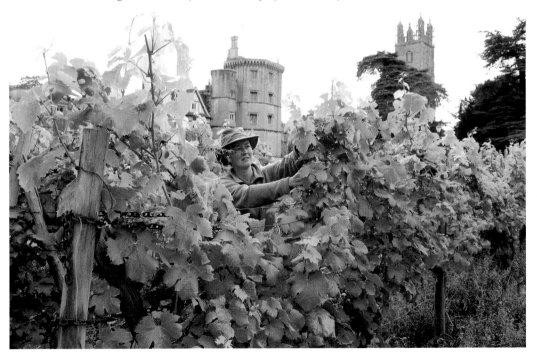

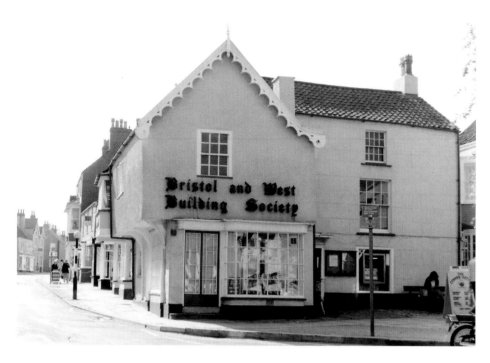

Building Societies

Building societies were first founded in the 1830s and they were a prominent feature in all High Streets until the 1980s. Over a thirty-year period they all but disappeared. The Bristol & West Building Society was founded in 1850 and ceased to be a building society when it was taken over in 1994 by the Bank of Ireland. The Britannia relinquished its building society status in 2009 when it merged with the Co-op Bank.

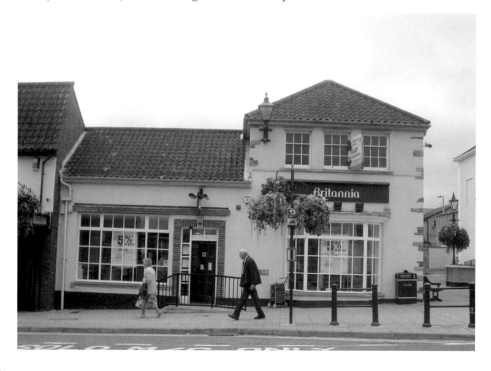

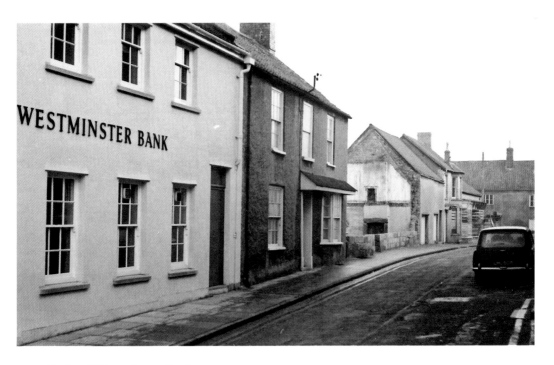

National Westminster Bank

The Westminster Bank seen from Silver Street was located on the corner with the High Street. The business transferred to the National & Provincial branch on The Plain when the two banks merged to become National Westminster Bank in 1968.

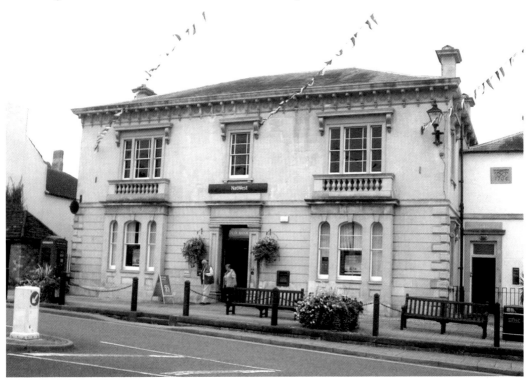

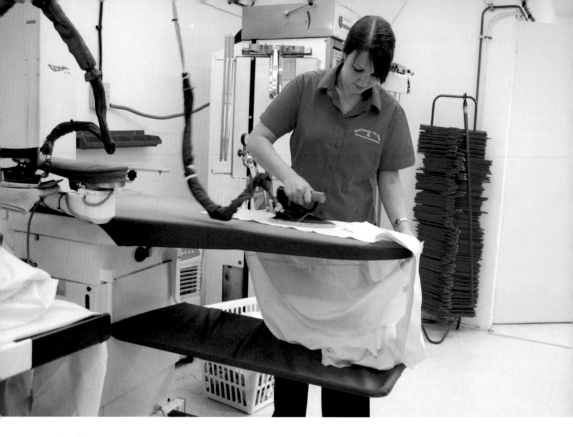

In Service

The shop "HARD PRESSED FOR TIME?" carrying out ironing and laundry services at 7, High Street (above). Two maids at West Shen, the home of Francis Grace, in the 1930s.

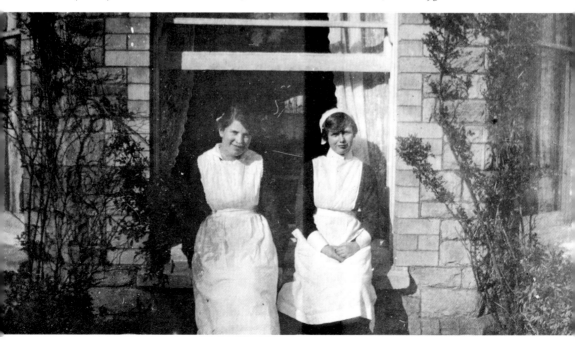

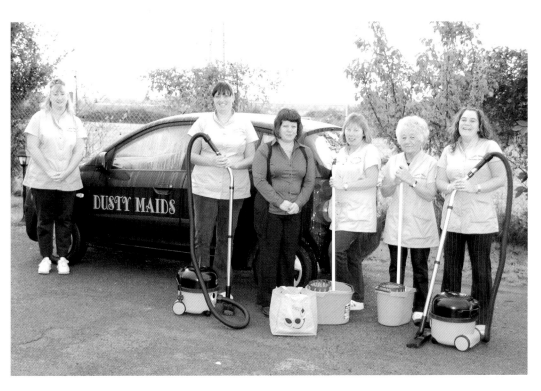

Maid Service
The uniforms are different, as are the cleaning tools and the mode of transport.
O.E. Thurston's maid *c.* 1890 and Dusty Maids 2009.

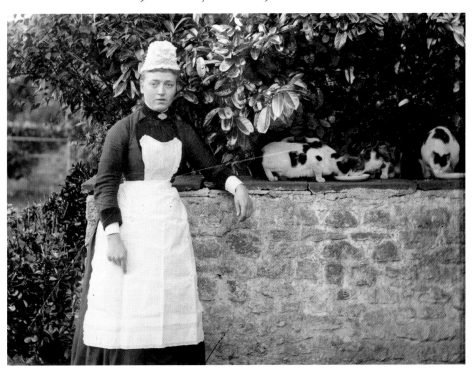

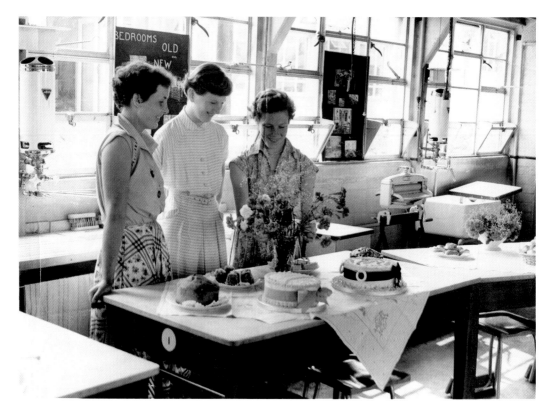

Domestic Science

1954: Thornbury Secondary School based at Gillingstool when girls were taught housewifery (note the mangle and the word "bedrooms" written on the blackboard). 2010: boys and girls are now taught food technology at Castle School.

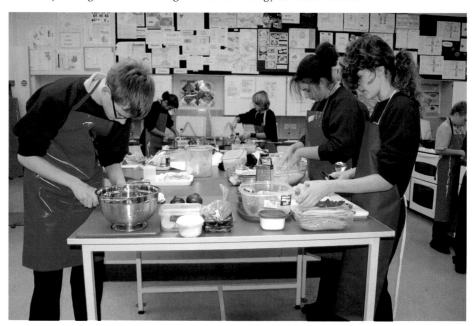

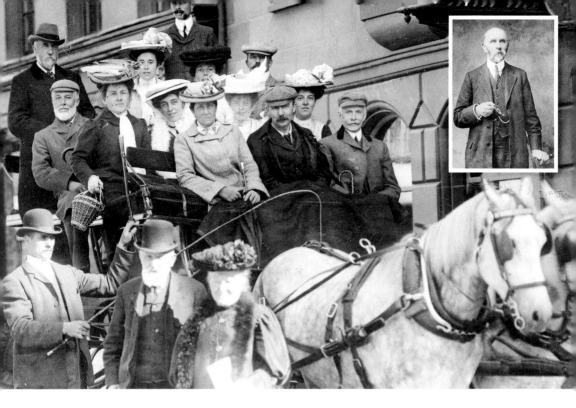

Electioneering

Edmund Cullimore is standing far left at the back of the coach, electioneering for local elections. His photograph seen on his election address is inset. Steve Webb, third right, seen electioneering. He became the first MP for the new constituency of Thornbury & Yate in 2010. When he was appointed to the Government as Minister of State for Work & Pensions he was in a group of the first Liberal Democrats ever appointed to Government posts.

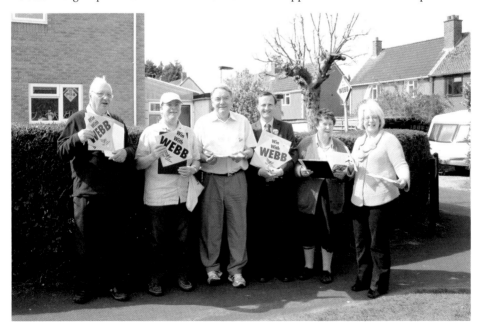

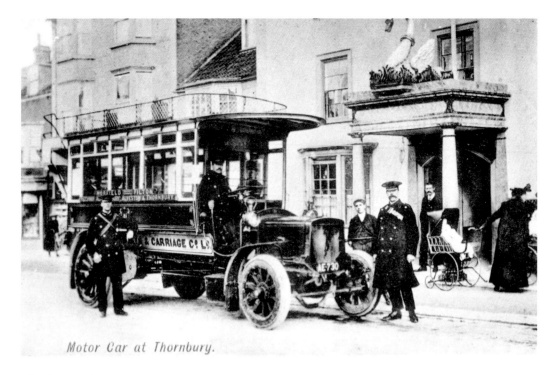

Motor Car at Thornbury.

Clippies & Drivers

The motorised bus service came to Thornbury in 1906 and immediately proved popular. However, one egg seller reputedly refused the bus and still walked into Bristol so that her profit was not diminished. The photographs are from the days when buses had both a driver and ticket collector (called a clippie because he would "clip" the ticket to show that it had been used).

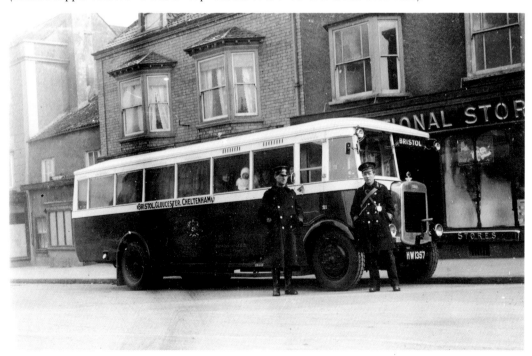

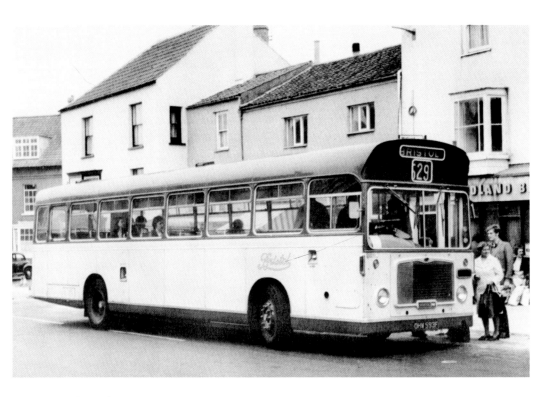

Buses & Banks

Approximately forty years apart, both the style of bus and the bus operator have changed. So have the banks. In the earlier photograph the Midland Bank (now HSBC) occupied the building on the right that is now Lloyds Bank.

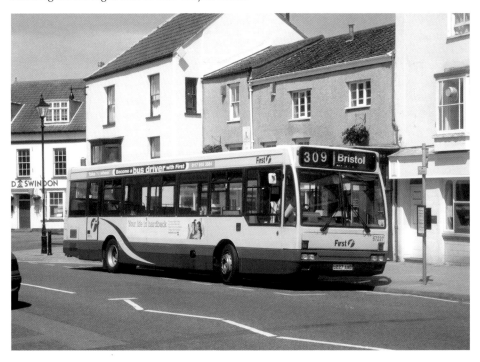

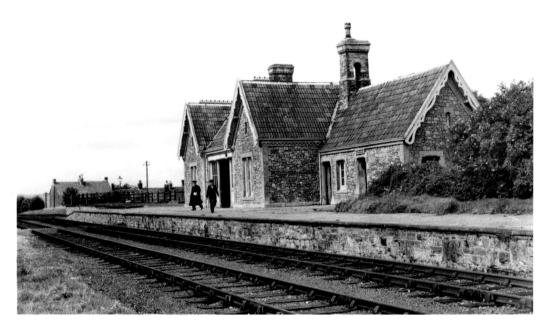

Thornbury Railway Station

Thornbury Station was opened by the Midland Railway on 2 September 1872. Train passengers had to travel to Bristol via Tytherington, Iron Acton and Yate, which was costly and time consuming. Regular passenger services closed in 1944 and the goods service finished on 26 June 1966. Midland Way (below) marks the site of the former Midland Railway.

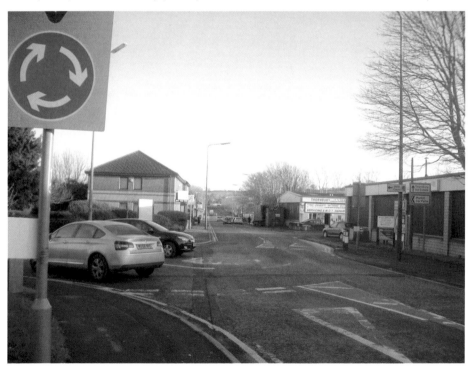

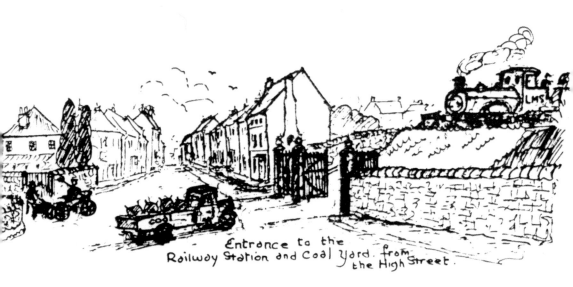

Entrance to the
Railway Station and Coal Yard from
the High Street.

Thornbury Railway Station

Local artist Jeff Screen's memories of the station approach as seen looking down the High Street. A turntable was used to turn the engines round because Thornbury was the end of the line. On Thornbury industrial estate Cooper Road and Short Way are named after former railwaymen, stationmasters Charles and Philip Cooper and engine driver William Short.

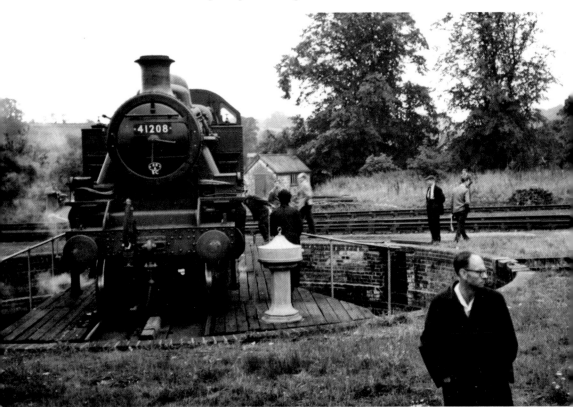

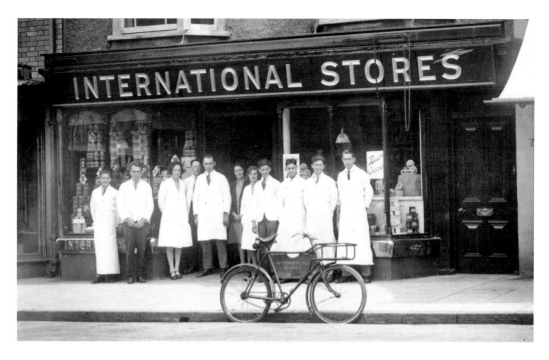

Service with a Smile

International staff at 11, High Street in 1927. Below: Barclay Riddiford at 51, High Street. Riddiford's Stores was established in 1929 when Barclay's father Lionel purchased the business from Dent's. Barclay's son and grandson currently work in the business with him.

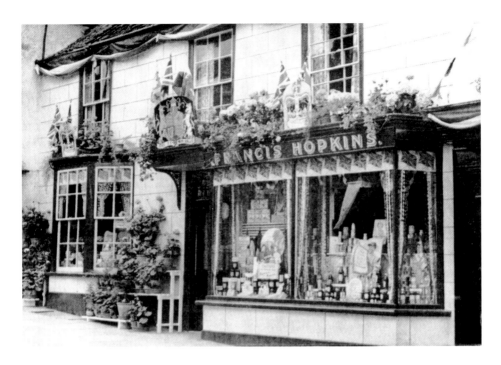

Grocer's

In 1950 half the grocery trade nationally was in independent hands. But in that year the first self service supermarket opened and since that date the growth of major chains has been remorseless. Francis Hopkins started up his grocery business in 1933, at the age of 19, trading at first out of a second-hand car. His shop on the High Street, opened in 1937, is seen here decked out for the Coronation of Queen Elizabeth II in 1953.

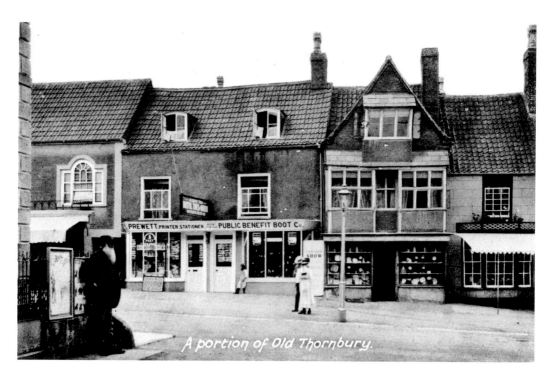

A portion of Old Thornbury.

The Oldest Family Business in the High Street

The Prewett family started business in the High Street in the late nineteenth century. When Albert Prewett retired in 1936 the shop was taken over by his daughter, Madge, and her husband Percy Horder.

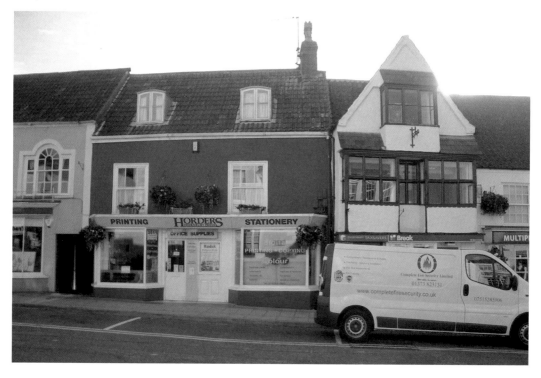

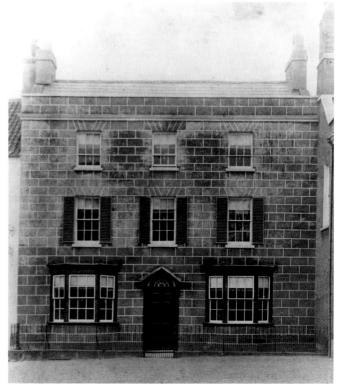

Savery's

The Saverys came to Thornbury in 1871 and moved to their current location in 1898. They changed the bottom floor to a large shop and re-named it Sheffield House to reflect their ironmongery and engineering business. Previously the property had a tradition of being occupied by doctors of medicine dating back to 1791.

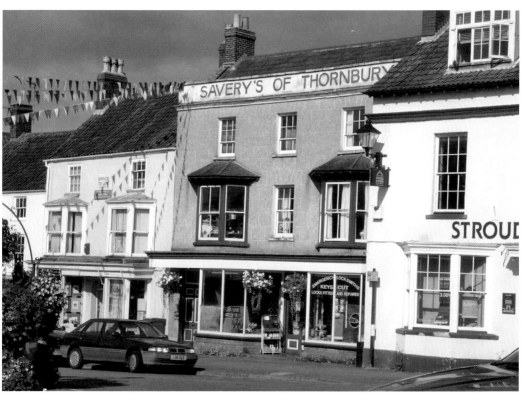

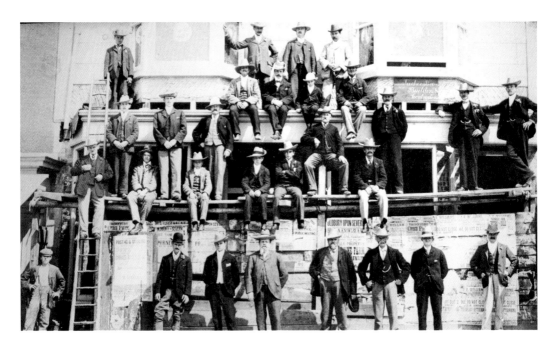

Industrial Thornbury

Above: builders, decorators & funeral directors Tucker Brothers in 1901 building Coronation House (see page 36). The firm was based in St John Street from 1856 for just over 100 years. Below: the sawmill being re-built following a major fire. It was owned by Edmund Cullimore (seen on page 65). He was Thornbury's main employer and also owned a brickworks as well as having interests in the Thornbury gas and electricity companies. The inset shows the sawmill some fifty years after rebuilding.

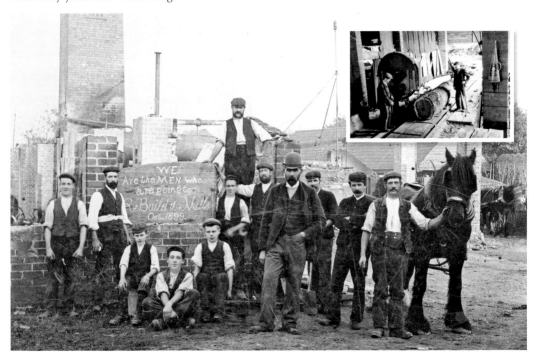

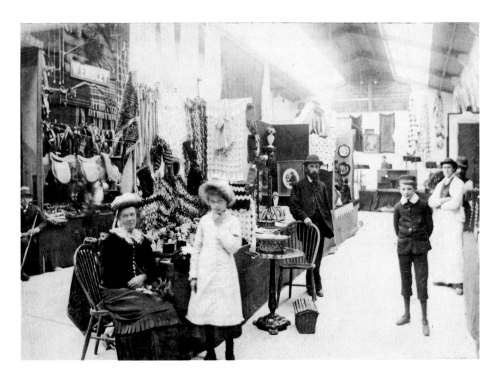

Thornbury Castle Real Tennis Court

Thornbury Castle had a tennis court where real tennis could be played. The court was often used for other events such as the industrial exhibition above and social events such as those below.

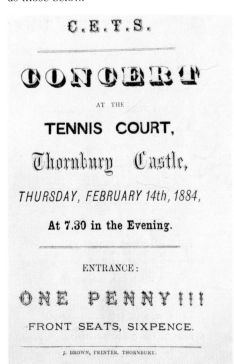

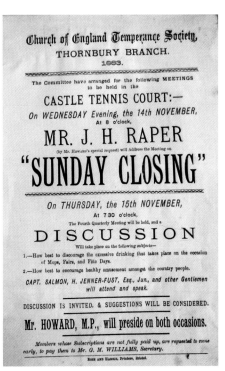

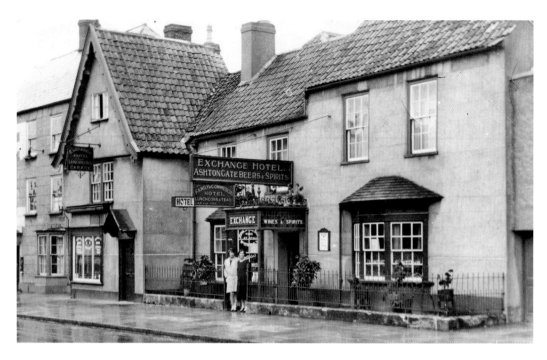

The Knot of Rope

The Knot of Rope was known as The Exchange until the early 1980s. Having been a free house (see page 15), the pub became part of Ashton Gate Brewery estate in 1920. Several breweries owned it subsequently. In the 1980s the Government forced most brewers to sell their pub chains to avoid being monopoly brewers and distributors of beer.

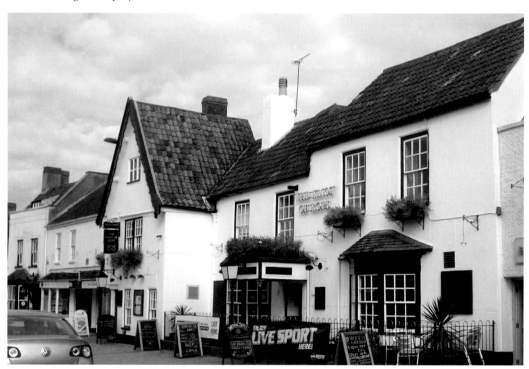

Queens Head

The pub, located on the corner of the High Street and Chapel Street, was rebuilt in 1911. It ceased being a pub in 1958 and has since been a doctor's surgery and chartered accountants offices (Burton Sweet), and is now a café. The block of stone that can be seen on the right hand bottom corner of the building was possibly intended to protect the wall from horse-drawn vehicles coming too close at a time when there were no pavements. There used to be another on the corner of Eyles & King's shop on St Mary Street/ Horseshoe Lane (see page 20).

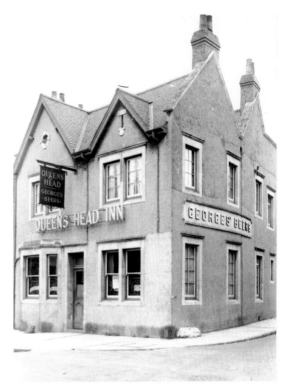

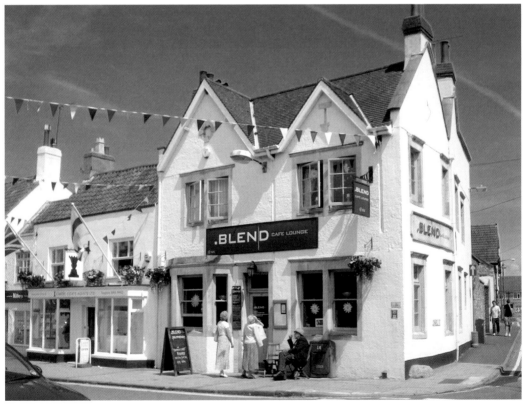

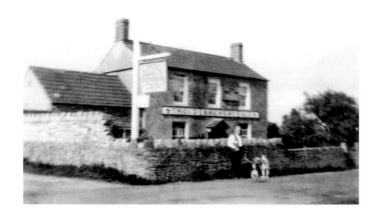

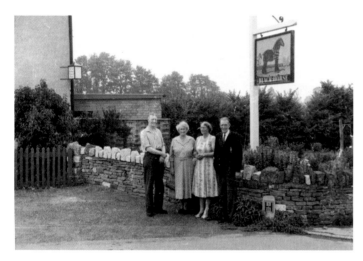

The Black Horse
The Black Horse in
Grovesend Road was
originally a beerhouse
(unable to sell spirits)
and was known to exist
in 1851. Cecil Palmer,
landlord from 1961 to
1970, is seen on the left
of the group before the
building was demolished.
The new pub was built
in 1962.

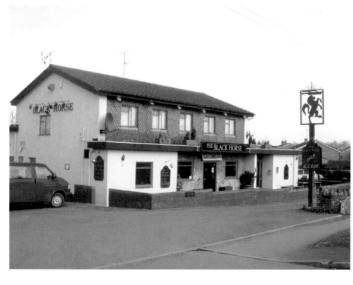

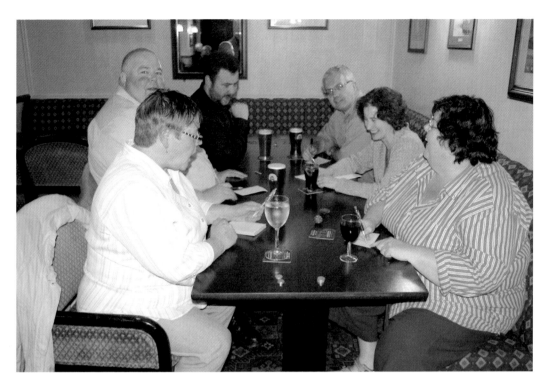

Entertainment at the Black Horse
In the original Black Horse darts and the piano were major forms of entertainment. Other more recent entertainments currently include quiz nights (above) and big screen sport.

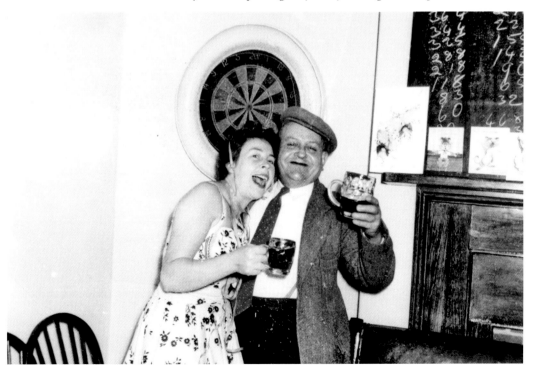

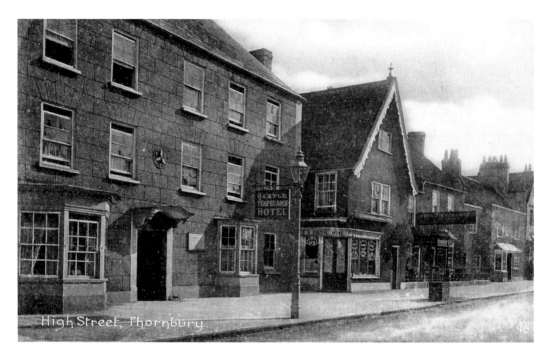

High Street, Thornbury.

Temperance Hotel
The Castle Temperance Hotel was opened in 1880 in St. Mary Street where it remained until 1889 when it transferred to the High Street. The main sponsor was Sir E. Stafford Howard who lived at Thornbury Castle and was a staunch advocate of temperance. It later became the Picture House (see next page) and is now divided into financial services offices.

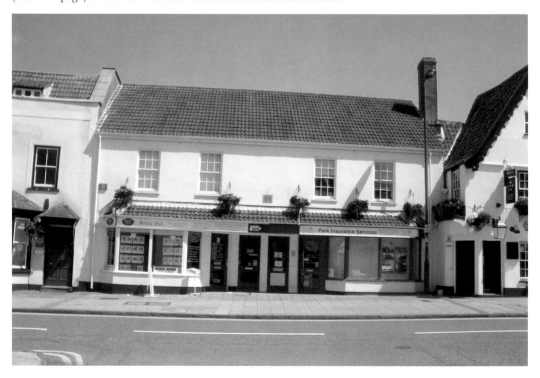

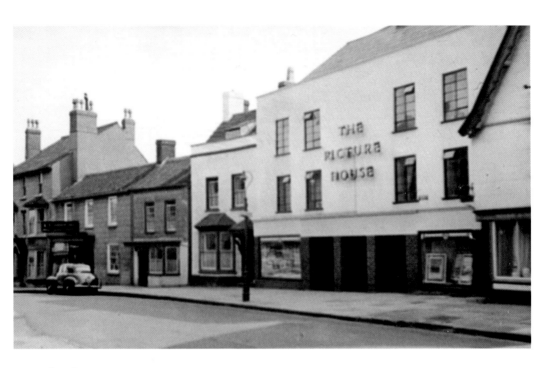

The Picture House

The Picture House was opened in 1919 in the silent movie era. It was never profitable, apart from during the Second World War years, and closed in 1959. It was the Cullimore/Grace family who built, financially supported it and ran it throughout its existence.

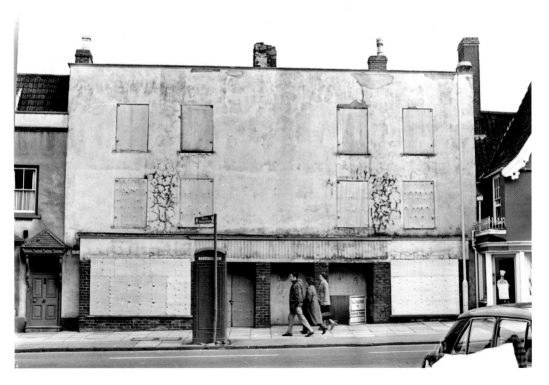

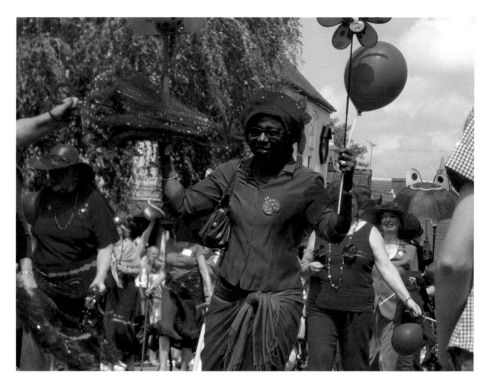

The High Street as a Meeting Place

The High Street has always been the town meeting place. On the 18 September 1991 Princess Diana opened the music centre at the Castle School and then met Thornbury people. Above: a colourful display from the 2009 carnival.

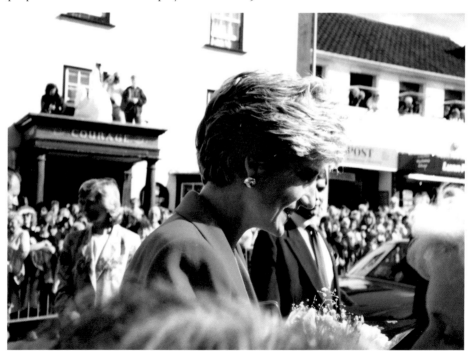

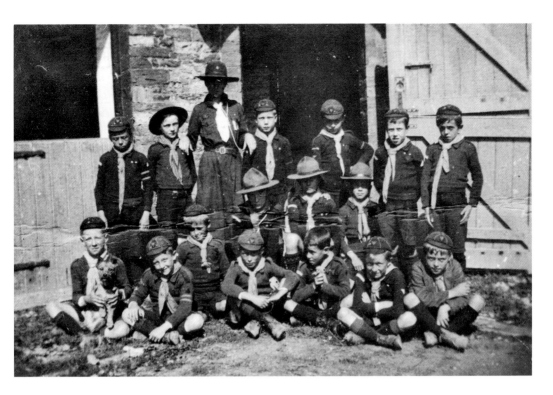

The Cubs

Above: the 1st Thornbury wolf cub pack of 1919. Below the Mowhawks cub pack includes girls. Girls were first allowed to join the scouting movement in the 1990s. The scout hut is now named Sinclair Hall to celebrate the twenty-five years that George Sinclair devoted to the scout movement in Thornbury.

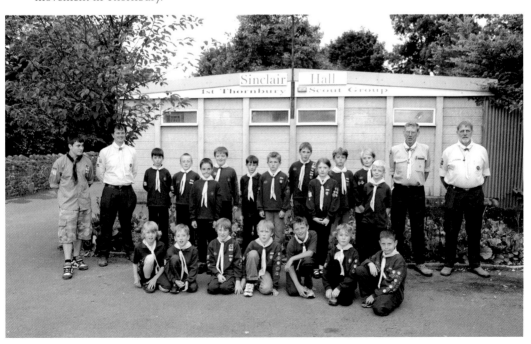

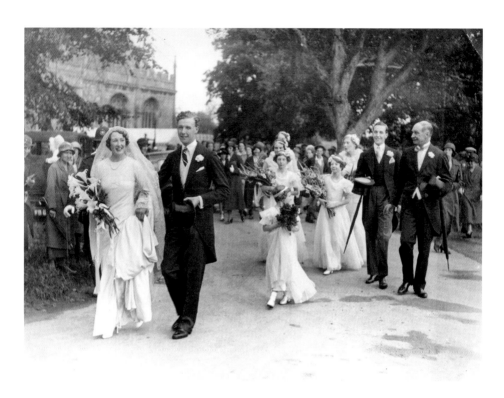

A Traditional Wedding and a Modern Wedding

Bride Miss Anne Violet Howard of Thornbury Castle and groom John Cahill lead a wedding procession. Sir Algar Howard, the bride's father, is seen on the right. Below: the bride and groom lead a family procession of their children, grandchildren and other relatives after their marriage at Thornbury Castle. It was the second marriage for both bride and groom, who met on the internet.

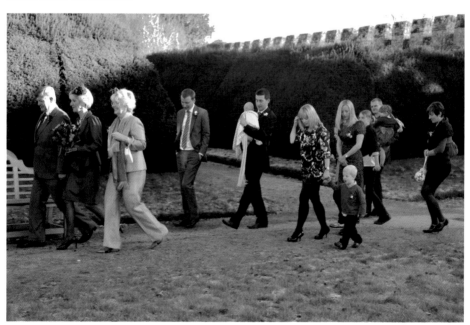

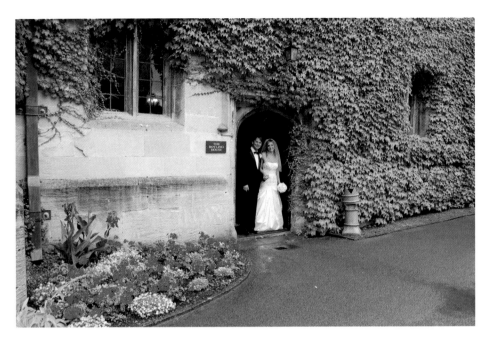

A Modern Wedding and a Traditional Wedding

Getting married in exotic foreign climes: a couple from Dothan, Alabama, USA, get married in the Tudor Hall of Thornbury Castle (above). Weddings were first allowed in hotels in 1995. Thornbury chimney sweep Albert Poulton attends a wedding to bring good luck to the bride in the 1950s.

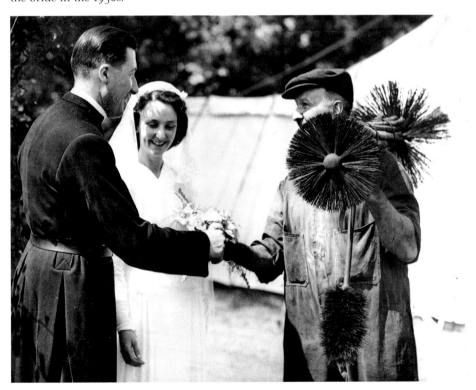

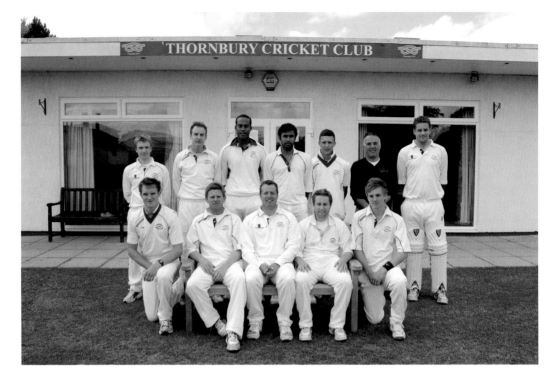

Thornbury Cricket Club

The 1877 Gloucestershire County Cricket Club (below) included two regular Thornbury players: bottom right Dr. E. M. Grace, who practiced medicine in the town, and his brother Dr. W. G. Grace seated beside him. Their brother Fred is holding the ball in the back row. All three played together for England against Australia. The county side still play benefit matches against the Thornbury club.

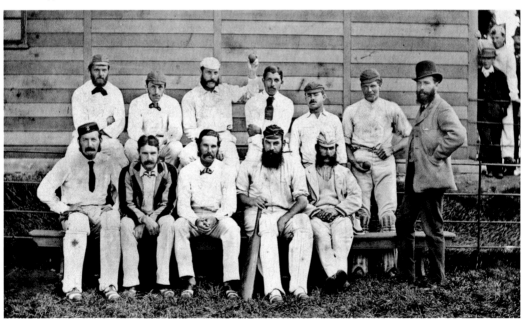

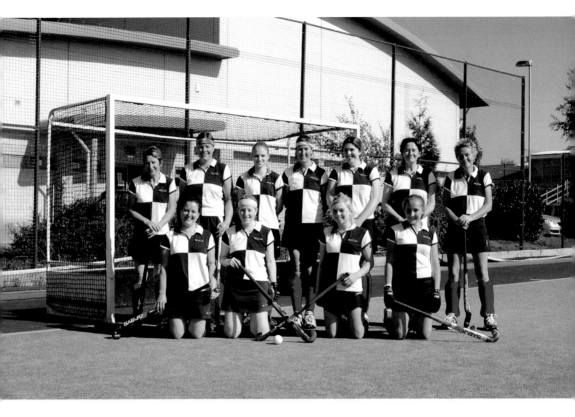

Hockey
Thornbury Hockey Club now plays on the Astroturf of the Castle School (above). Long skirts and ties were fashionable with Thornbury Grammar School hockey teams during the First World War.

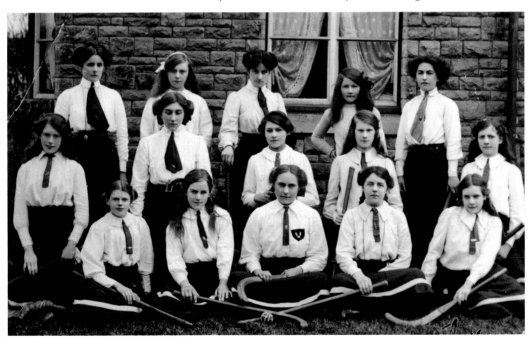

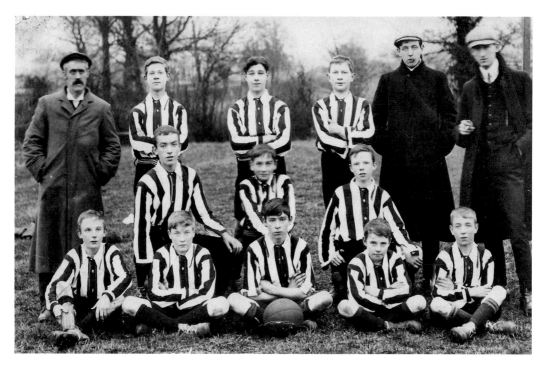

Football

An all-girl team playing for Thornbury Falcons, something that would not have been possible in 1906. The 1906 team has not done a sponsorship deal on its shirts.

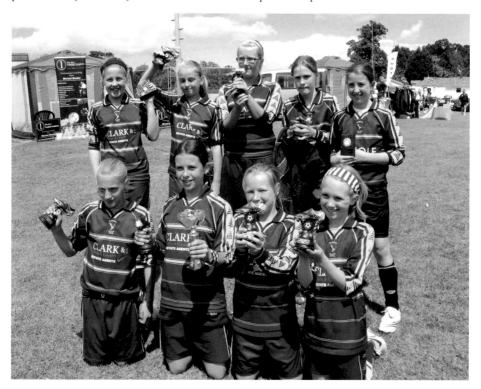

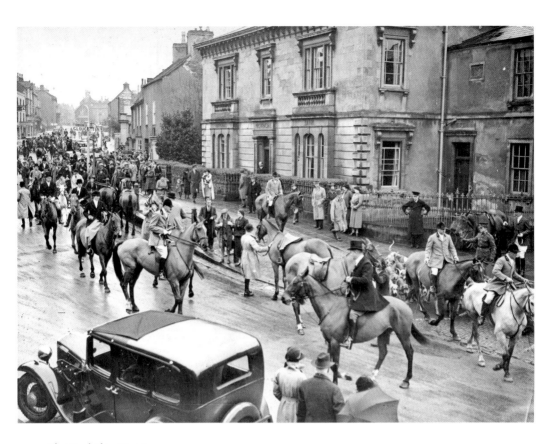

The Berkeley Hunt

The Berkeley Hunt has been a regular visitor to Thornbury for generations. On 18 February 2005 law changes resulted in the hunt trailing scent trails rather than hunting foxes with dogs.

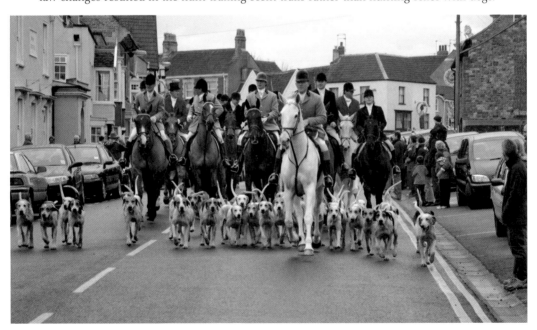

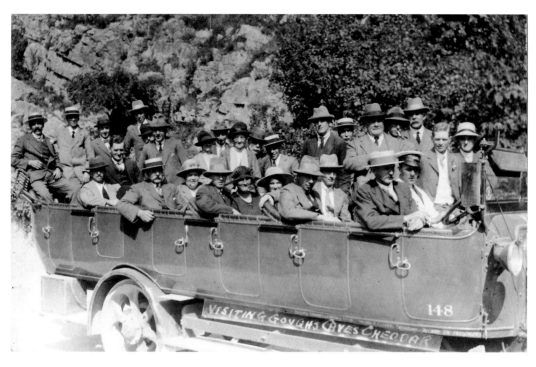

A Day Out

In the 1930s a day out was by charabanc for Thornbury folk, possibly Baptists. Nowadays travel is more luxurious, such as when Mike's Travel transports a party from U3A to St Fagans, Cardiff.

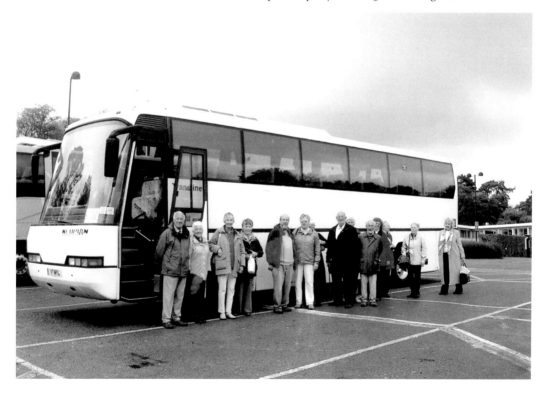

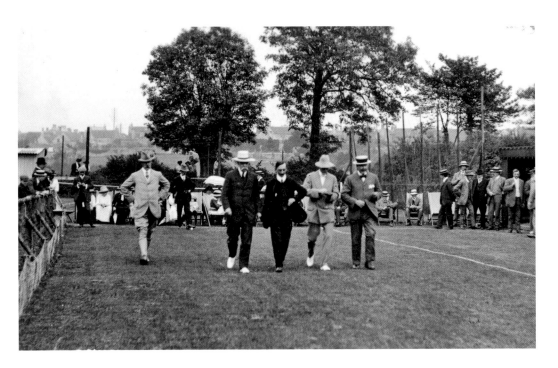

Bowls

The above photograph is believed to record the opening of Thornbury Bowls Club. At that time women were only allowed to make the tea. Eventually they were allowed to have a ladies section which was followed by mixed teams. Now there are unified teams such as Thornbury Indoor Bowls Club seen entertaining Gloucester Vice-Presidents at the Leisure Centre.

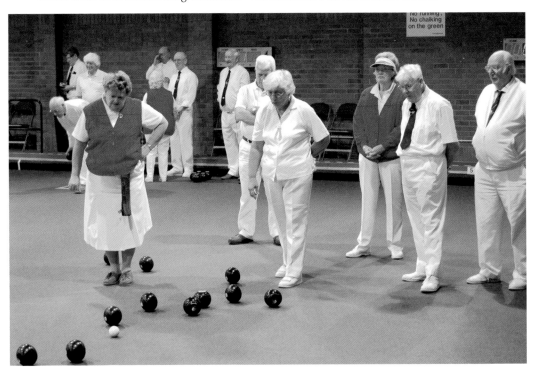

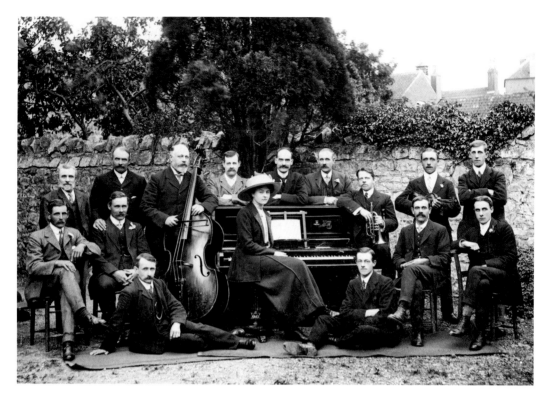

Orchestra

Miss Ethel Hobbs seems to have been given honorary status by being allowed to join the Thornbury Brotherhood as seen in 1912. Thornbury Orchestra in rehearsals, where women play both a prominent part as well as an instrument!

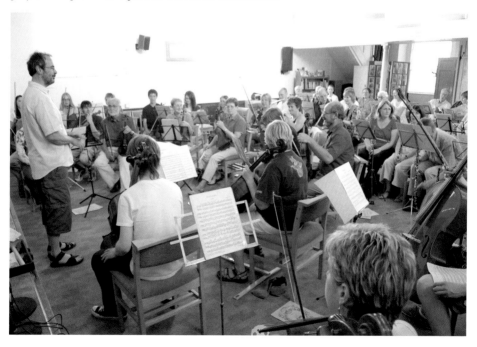

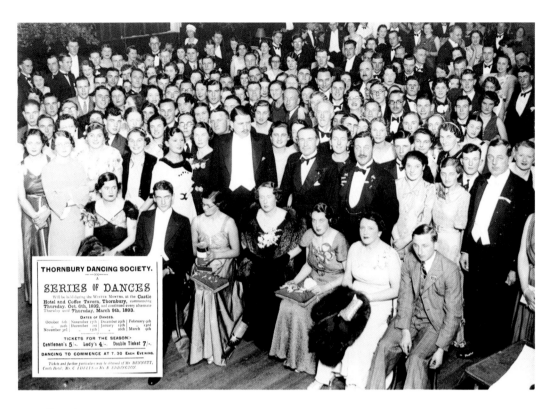

Dancing

1892/3: The inset shows an advert for dancing at a cost of 7/- (35p) per couple for twelve dance sessions. 1938: Thornbury Young Conservatives at the Cossham Hall, some dressed in tails. 2009: A Tea Dance at the Cossham Hall.

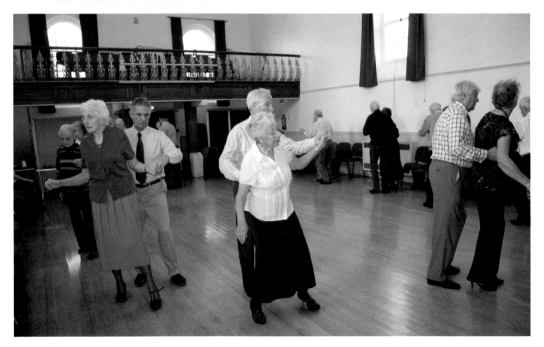

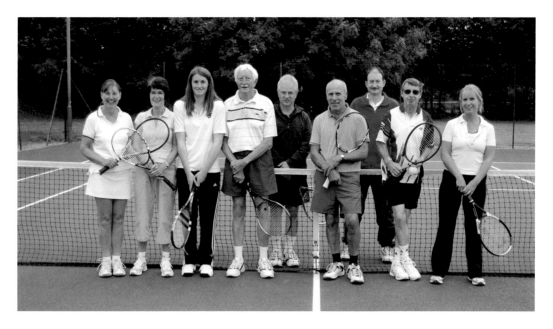

Anyone for Tennis?

In 1925 elegance and style were more important than today's more practical casual outfits. The tennis courts were on part of Lower Marlwood Farm's land. The courts were originally lawn tennis courts but changed to hard courts in the 1960s. Along with the bowling green they were donated to the town in 1947 and incorporated into the Mundy Playing Fields.

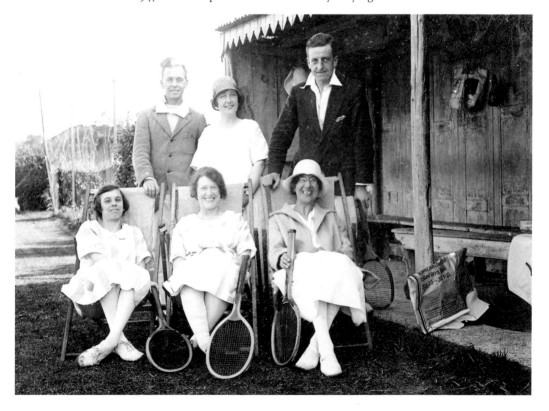

Ancient and Modern

Alan English and Marjorie Symes playing in a demure way suited to the times. Alan English was born in 1904 and so this picture was probably taken around 1910. Fast forward 100 years and activities are livelier at the skate park which is situated behind the Leisure Centre in Bristol Road. Separated by approximately a century, the fashions have also changed with the contemporary style known as "the sag" allowing the display of patriotic underwear.

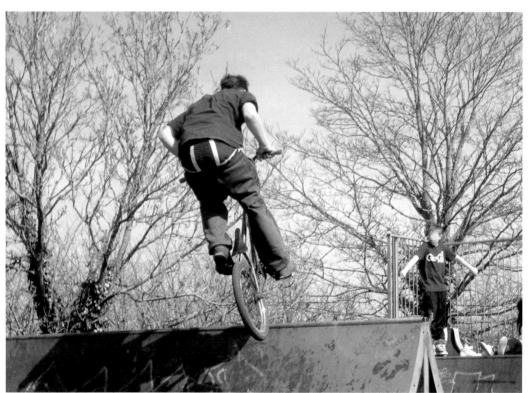

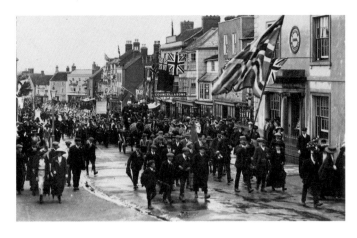

A parade in Thornbury
High Street early 1900s.

Acknowledgements

We would like to thank all those people who have donated or lent photographs to Thornbury & District Museum, making this book possible. Particular thanks go to Mike Edwards, Ian Hartley, Nick Large and Mrs E. Screen for their support of this project.

The photograph of the Industrial Exhibition on page 75 is courtesy of Gloucestershire Archives (ref. D4764/3/1) and remains their copyright.

The coloured photograph on page 84 is courtesy of Alec Walker, photographer, Aust.

The co-operation of the management and staff of Thornbury Castle Hotel and other businesses and groups is greatly appreciated.

Many of the contemporary photographs were taken by John Rendell, and Brian Howe contributed greatly to the text.

Many colleagues in the museum have contributed to this book including Heather Palmer and Sandra and Chris Doig. Sandra and Chris have created an excellent website www. thornburyroots which is a mine of information on all things Thornbury.

All proceeds of this book go to Thornbury & District Heritage Trust and will support Thornbury & District Museum.

The Trust has endeavoured to locate the origins of all the pictures in this book and to seek permission for their reproduction. We apologise to any one that we have missed in this search and hope that we have not given offence.

To contact the Trust please write to:

Thornbury & District Heritage Trust
Town Hall
35 High Street
Thornbury
BS35 2AR

Or via email to: enquiries@thornburymuseum.org